An Illustrated Dictionary of
SURREALISM

An Illustrated Dictionary of
SURREALISM

by
José Pierre
translated from the French by
W.-J. Strachan
Chevalier des Arts et des Lettres

BARRON'S · Woodbury, N.Y.

Layout design by Robert Maillard

FIRST U.S. EDITION PUBLISHED 1979
BY BARRON'S EDUCATIONAL SERIES, INC.
113 CROSSWAYS PARK DRIVE
WOODBURY, NEW YORK

ISBN 0-8120-0987-8

PRINTED IN FRANCE BY IMPRIMERIE MUSSOT, PARIS

TRANSLATOR'S NOTE

Readers will notice that I have occasionally retained the original French title of a work described in the captions. Sometimes for the obvious reason that a literal or satisfactory rendering would be impossible; for example: *'La Femmoiselle'* (Hérold), *'Loplop et La Belle Jardinière'* (Ernst). Sometimes where, although the title presents no real problem of translation, the work is traditionally known under its French title (such as *'La Femme 100 Têtes'* by Ernst). *'Brûlage'* by Ubac is a special case, since the title refers to the process by which it was produced and which I have explained in a note. There are occasions when a French title seems to lose its overtones in translation—I am thinking particularly of Masson's *'Jeune fille au bâillon vert à bouche de pensée'*—but by and large we have become familiar with the surrealist works in question through their Anglo-Saxon titles, and certainly no evocative ring seems lost in such examples as Giacometti's *'The Palace at 4.00 p.m.,'* Dali's *'The Persistence of Memory'* or Duchamp's *'The Bride stripped bare by her Bachelors, even.'*

The principles I have applied to the captions obtain *a fortiori* to some of the item-headings and words in the text, some of which are so closely identified with the French surrealists as to have become universally known by the terms they coined or used and which I have therefore retained in the original French: *'Amour fou,' 'humour noir,' 'Immaculée conception,' 'point suprême.'* However, wherever any such terms or phenomena are familiar to an Anglo-Saxon public, I have naturally translated them— 'convulsive beauty,' 'decalcomania of chance,' 'magnetic fields' etc. If it seems inconsistent to have given the English equivalent of *'cadavre exquis'* ('exquisite corpse'), but retained the French for another surrealist game *'L'un dans l'autre,'* it is simply that through descriptions and illustrations the former is more generally known than the latter. As for the retention of the French term *'romans noirs'* despite the fact that the genre the 'Gothic novel' or 'novel of horror' which inspired it was English, those who have read contemporary French examples (*Au Château d'Argol* or *Un Beau Ténébreux* by Julien Gracq) will realize that the respective labels are not synonymous. Nor is there a satisfactory English equivalent for the term, coined by Dubuffet,

'art brut' and the graphic processes: 'collage,' *'frottage,'* *'fumage,'* *'grattage,'* only the first of which is generally accepted un-italicized in English texts.

Many of the 'token' quotations, though evocative as leads-in to certain poets are, because of their surrealist nature and absence of context, esoteric and ambiguous in the French original. Translated, these snippets lose the qualities of resonance and semantic allusion which can to some degree be caught only in translations of more extensive passages. Where the loss is particularly apparent, I have quoted the French, followed by a more or less literal translation in brackets. In this I am following a precedent set by the translator of Lewis Carroll's *Sylvie and Bruno* who,—when it comes to the Professor's Song, is content to quote the English and provide a literal translation which I quote in part* since it makes my point amusingly stet explains why in the cases of quotations from Deharme, Duits, Brunius and Char, I have followed this example— I hope sometimes less disastrously. Happily in some cases all is not lost in the translation process as in Arp's 'Je dors et j'attends qu'il me pousse des feuilles' and the 'J'ai craché de l'encre dans la poêle à frire' of Gisèle Prassinos and even the lines by Benjamin Péret : 'Mais si les alouettes faisaient la queue à la porte des cuisines—pour se faire rôtir—si l'eau refusait de couper le vin—et si j'avais cinq francs— il y aurait du nouveau sous le soleil.' It is worth noting that the author of the dictionary uses the English word 'nonsense' in his entry on Péret, and many readers will be glad that the dictionary has not neglected this link with literary surrealism *d'outre-Manche*.

* Lewis Carroll, *Sylvie and Bruno* (verse 1 of the Professor's Song). Translated by Fanny Deleuze, Editions du Seuil, 1972.

Little birds are writing	Les petits oiseaux écrivent
Interesting books	Des livres intéressants,
To be read by cooks.	Très lus dans les cuisines.
Read, I say, not roasted,	Lus, dis-je, et non rôtis.
Letterpress when toasted,	La typographie sur un gril
Loses its good looks.	Perd sa belle apparence.

THE TRAJECTORY OF SURREALISM

1919. Three young poets, Aragon, Breton and Soupault, found the review *Littérature*. A shared admiration for *Les Chants de Maldoror*, published half a century before by Isidore Ducasse, comte de Lautréamont, brings them together. In attempts to rediscover the secret of that work and encouraged by Freudian psycho-analysis—which Breton had studied and tried out-they experiment with 'automatic,' that is uncontrolled, writing. Breton and Soupault compose the first surrealist book, *Magnetic Fields*, on this principle. In Cologne, Max Ernst, under the influence of de Chirico, creates surrealist collage. Vaché commits suicide at Nantes.

1920. Tzara, who had founded the Dada movement in Zurich in 1916, is enthusiastically welcomed by Picabia and *Littérature*. With the cooperation of his new friends, he introduces the provocative style of dadaist demonstrations to the Paris theatre.

1921. Breton and his friends soon tire of the repetition of the same effects, as they do of Tristan Tzara's confessed weakness for the stage. The 'Barrès case' reveals differences of opinion between them. However, valuable contacts are made with poets (Eluard and Péret) and painters (Duchamp and Man Ray).

1922. Ernst arrives in Paris. Baron, Crevel, Desnos, Limbour and Vitrac join Breton and his friends. Spiritualist techniques of trance-communication provide an additional confirmation of the validity of automatic writing. Breton proposes the term 'surrealism' (coined by Apollinaire) to designate the whole field of relevant investigations.

1923. A brawl on the occasion of the performance of Tzara's *Cœur à gaz* marks the final break with Dada.

1924. The aggressive pamphlet *Un cadavre*, inspired by the death of Anatole France, rouses the hostility of the press and intellectual circles towards the surrealists. Publication of the (first) *Surrealist Manifesto*. For a brief time de Chirico draws close to the surrealists. M. Lübeck, Malkine, M. Morise, Naville, Queneau appear on the scene. A Bureau of Surrealist Research is opened at 15 rue de Grenelle, Paris. Masson and Miró create the first artifacts inspired by surrealist 'automatism'.

1925. On the occasion of the Saint-Pol-Roux banquet, the surrealists cause a new scandal by flaunting their antipatriotic views. The tract *La Révolution d'abord et toujours* ('Revolution first and always') stresses the importance now assumed in surrealist eyes by the problem of social revolution. Artaud takes on the management of the Surrealist Bureau and infects the group with his own enthusiasm. Among the newcomers to the movement are P. Brasseur, Duhamel, Leiris, Prévert, Tanguy. The first surrealist exhibition brings together works by Arp, de Chirico, Ernst, Klee, Masson, Miró, Picasso, Man Ray, P. Roy. Max Ernst invents the process of *frottage* (q.v.). *'Le cadavre exquis'* ('The exquisite corpse') is the first of the surrealist 'games' (q.v.).

1926. Arp goes to live in Meudon. Tanguy paints his first surrealist pictures. In Belgium surrealist activity centres round Magritte, Mesens, Nougé. Picasso moves openly towards the surrealists. Artaud and Vitrac found the *Théâtre Alfred Jarry*. Breton meets Nadja. Inauguration of the *Galerie Surréaliste* in the rue Jacques Callot, Paris.

1927. Aragon, Breton, Eluard, Péret and P. Unik join the French Communist Party, but almost immediately find themselves faced with insurmountable barriers. Artaud, Soupault and Vitrac are expelled from the group.

1928. The issue of the review *Le Grand Jeu* brings about a fleeting *rapprochement*. Breton publishes his *Le Surréalisme et la Peinture*.

1929. Publication of the Second Surrealist Manifesto, marking a decisive turning in the history of the movement. Baron, Desnos, Leiris, Limbour, Masson, Prévert and Queneau leave the scene and their places are taken by Buñuel, Char, Dali and Giacometti. Rigaut commits suicide. There is a reconciliation between Tzara and Breton.

1930. Rallying round Georges Bataille, several of the surrealists criticized in the Second Manifesto reply in the pamphlet *Un Cadavre*. No. 1 of the review *Le Surréalisme au service de la Révolution* is published. J. Caupenne and Sadoul address an insulting letter to the candidate who passed out first from the military school of Saint-Cyr. Rightist thugs sabotage the showing of the film *L'Age d'or* by Buñuel and Dali and destroy the surrealist canvasses exhibited in the cinema foyer. The film is banned by the police. Aragon and Sadoul, sent out as repre-

sentatives to defend the surrealist position at the Second International Conference of Revolutionary Writers at Kharkov, fall victims to Stalinist wiles.

1931. From convergent suggestions from Breton, Dali and Giacometti emerges the notion of 'surrealist object' (q.v.).

1932. Aragon and Sadoul break with the surrealists. Brauner, Caillois, Hugnet, Mayoux, J. Monnerot, M. Oppenheim, H. Pastoureau and G. Rosey join the movement.

1933. Publication of the first number of the review *Minotaure*.

1934. Following the Fascist *Putsch* of February 6, Breton launches a 'Call to Arms' which wins wide support among the intellectuals. The surrealists espouse the case of Violette Nozières, accused of having poisoned her cruel father. Dominguez, D. Maar, Oelze, Gisèle Prassinos and Seligmann join the group.

1935. Breton slaps the face of the Russian writer, Ilya Ehrenbourg, in the street for insulting the surrealists. As a result he forfeits the right to speak at the 'Congress of Writers for the Defence of Culture'. Crevels commits suicide. Breton publishes 'Of the Time when the Surrealists were right' which sets the seal on the irreparable break with Stalin communism. With Bataille he founds the group 'Counter-attack'. Picasso composes surrealist poems. Brunius, Mabille, Paalen come on the scene. International exhibitions of surrealism take place in Copenhagen and in the Canary Islands. In Prague Breton and Eluard become aware of the deep appreciation of the movement on the part of Czech surrealists and Marxists. Discovery of Bellmer.

1936. In London, the opening of an international exhibition of surrealism of paramount importance. At the outbreak of the Spanish Civil War, Péret joins the Trotskyists of the P.O.U.M. (*Partido Obrero de Unificación Marxista*, founded Feb. 1936.) in Barcelona (the 'Workers Party of Marxist Unification) and then the Anarchists on the Aragon front. Breton at a meeting denounces the first Moscow trials. Dominguez describes the process of 'decalcomania without preconceived object' (q.v.). Exhibition of surrealist objects, Galerie Ratton, Paris. 'Fantastic Art, Dada, Surrealism' exhibition at the Museum of Modern Art, New York.

1937. On his return from a trip to Mexico, Artaud is interned in a mental institution. An international exhibition of surrealism

takes place in Japan. Breton opens the Galerie Gradiva in the rue de Seine, Paris.

1938. In Paris, the International Exhibition of Surrealism at the Galerie des Beaux-Arts is an event: 70 artists from 14 different countries participate. Breton meets Trotsky in Mexico and together they draw up the manifesto 'For an Independent Revolutionary Art'. On his return Breton breaks with Eluard who has just collaborated in the Stalinist review *Commune*. With Francès and Onslow-Ford, Matta heads a new offensive of 'automatism' in painting. Masson makes it up with Breton. Brauner suffers the loss of an eye in a brawl among some surrealists.

1939. As a result of the war, the surrealists become dispersed. Breton and Péret are called up, Bellmer and Ernst are interned by the French authorities as German subjects, Matta and Tanguy settle in the United States, Paalen goes to Mexico.

1940. After the fall of France, a large number of the surrealists gather in Marseilles (q.v.) where they invent a card game. Lam appears on the scene. The Vichy régime bans the publication of the *Anthologie de l'humour noir*, compiled by Breton, but allows that of the *Miroir du Merveilleux* by Mabille. In Mexico City Moro and Paalen organize an International Exhibition of Surrealism.

1941. Breton is interned for a time in Martinique by the Pétainist authorities, but meets Césaire. He manages to get to the United States where he becomes the announcer of the 'Voice of America' broadcasts, put out for France. Ernst, Masson and Seligmann are likewise in the United States, Péret in Mexico.

1942. In New York, an international exhibition of surrealism is organized by Breton and Duchamp who, with Ernst, publish the review *VVV*. Newcomers: Donati, Duits, Hare, Robert Lebel, Dorothea Tanning, Isabelle and Patrick Waldberg, form a group centred round Breton, N. Calas, L. Carrington, Marcel Duchamp, Ernst and Matta. The surrealists' presence exercises a profound influence on American painters and sculptors through the intermediary of the Art of this Century Gallery and sympathetic artists such as Baziotes, Calder, Kiesler and Motherwell.

1944. Meeting between Breton and Gorky—decisive for the latter's future.

1945. Breton visits the Reserves of the Hopi and Zuñi Indians and writes his *Ode à Charles Fourrier*. In Mexico City Péret publishes his pamphlet *Le Déshonneur des poètes*, attacking the 'poetry' of the Resistance particularly aimed at certain tendentious poems, clandestinely circulated. Speeches made by Breton in Haiti contribute to the outbreak of the insurrection in the early days of 1946. Publication of Maurice Nadeau's *L'Histoire du Surréalisme*, vol. I.

1946. Breton's first act on his return to Paris is to give an open welcome to Artaud on his release from detention in a mental hospital. The surrealist group is reconstituted in an atmosphere of hostility, largely due to the cultural dominance of the Stalinites.

1947. Breton, Duchamp and Kiesler organize an international exhibition of surrealism at the Galerie Maeght, Paris, on the theme of a 'new collective myth'. In clearer terms than ever before the surrealists insist on the link that exists between art and poetry on the one hand, and between magic and hermetic philosophy (and alchemy in particular) on the other. The pamphlet *Rupture inaugurale* expresses the surrealist refusal to commit themselves to any political line whatsoever. Sabotage of a lecture on surrealism given by Tzara. Between 1947 and 1951 S. Alexandrian, J.-L. Bédouin, Dax, Duprey, J. Ferry, Gracq, Jouffroy, Legrand, Mandiargues, N. Mitrani, J.-P. Riopelle, S. Rodanski, I. Serpan, Schuster, C. Tarnaud come on the scene.

1948. Gorky commits suicide. Matta is expelled for having had some responsibility in this event. Brauner likewise, but for his disruptive behaviour. Number 1 of the review *Néon* is published. In Montreal, Borduas and the 'automatists' publish *Refus global*. In Paris, issue of the manifesto '*A la niche, les glapisseurs de Dieu*'.

1951. As a result of the 'Carrouges affair' (Michel Carrouges, a writer linked with the surrealists, confessed to being a practising Catholic), Henry, Hérold, M. Jean, Robert Lebel, H. Pastoureau, P. Waldberg are expelled from the movement. The surrealists are joined by the group 'L'Age du cinéma' (R. Benayoun, G. Goldfayn, A. Kyrou). The surrealists collaborate in the newspaper, *Libertaire*, the organ of the Fédération anarchiste.

1952. *Entretiens radiophoniques* between Breton and A. Parinaud

(These 'Conversations' consisted of a series of interviews on various aspects of Breton's career and articles, etc., of the period 1913-1952 broadcast by Radiodiffusion française March to June, 1952. They are published in the Series 'Idées' chez Gallimard). Publication of Number 1 of the leaflet *Medium*. Inauguration of the Galerie 'A l'étoile scellée', directed by Breton.

1953. 'Discovery' of Hantaï and Svanberg. Death of Heisler. Beginnings of a *rapprochement* between art critic Charles Estienne, defender of 'lyrical abstraction' and Breton. Picabia dies.

1954. With a great deal of flourish Breton and Charles Estienne launch 'tachism' against the common enemy, 'cold' abstraction. Thanks to the works of L. Lengyel, the surrealists 'discover' Celtic art. Ernst is expelled for having accepted the Grand Prix of the Venice Biennale. *Medium* becomes a magazine.

1955. Hantaï, J. Reigl and A. Saura withdraw. Death of Tanguy. F. Alquié publishes *Philosophie du Surréalisme*. Between 1955 and 1959, appearance on the scene of Benoît, V. Bounoure, Cabanel, Cárdenas, R. Ivsic, A. Joubert, Lagarde, Laloy, J.-J. Lebel, Le Maréchal, J. Mansour, Molinier, M. Parent, Silbermann.

1956. Pamphlets issued showing up the shameless Stalinism of the French Communist Party and saluting the Hungarian insurrection. Number 1 of the review *Le Surréalisme, même*.

1957. The surrealists denounce demonstrations of (Catholic) integrist and fascistizing inspiration organized by Hantaï and Mathieu.

1958. D. Mascolo and Schuster found the journal *Le 14 juillet* to rally the opposition of the intellectuals against the régime resulting from the *coup d'état* of May 13. Publication of the first number of *Bief*. Issue of pamphlet *'Démasquez les Physiciens, vides les laboratoires'* ('Unmask the physicians, empty the laboratories').

1959. Deaths of Duprey, Paalen, Péret. International Exhibition of Surrealism 'Eros' in the Galerie Daniel Cordier opens with the inauguration of Benoît's *L'Exécution du testament du marquis de Sade* ('Execution of the Testament of the Marquis de Sade'). Bellmer 'discovers' Schröder-Sonnenstern.

1960. Declaration called 'of the 121' concerning the Algerian war is prepared with the active cooperation of the surrealists.

In New York, an exhibition 'Surrealist Intrusion in the Enchanters' Domain'. *Tir de barrage*, a pamphlet denouncing Jouffroy's wrong-headed agitation. On the occasion of a tactical alliance between the group *'Phases'* various artists—and notably Alechinsky, Baj, H. Ginet, Gironella, Klapheck and Télémaque—make contact with the surrealists.

1961. Surrealist exhibition at Milan, Galleria Schwarz. Publication of Number 1 of the review *La Brèche*. Philippe Audoin, Camacho, C. Courtot, Der Kevorkian, A. Le Brun, De Sanctis and Sterpini come on the scene between 1961 and 1965.

1964. Breton protests against the Retrospective Exhibition of Surrealism organized at the Galerie Charpentier by Patrick Waldberg.

1965. The International Exhibition of Surrealism, *'L'écart absolu'*—which indicates the distance to be taken in relation to consumer society—opens at the Galerie L'Œil.

1966. Death of André Breton. The surrealists decide unanimously to continue their battle. Publication of Number 1 of *L'Archibras*. Arp, Brauner and Giacometti also die.

1967. 'A phala'—an international exhibition of surrealism opens at Sao Paulo. The surrealists participate in the voyage of the 'Salon de Mai' to Havana, organized by C. Franqui and Wifredo Lam. Death of Magritte.

1968. Thanks to the 'Spring in Prague', a surrealist exhibition, 'The Principle of Pleasure' takes place in Czechoslovakia. It provides the Paris surrealists with the opportunity of making contact with the surrealists of Bohemia and Czechoslovakia. A 'Prague Platform' is planned to decide on future ideas. The events of May are enthusiastically welcomed by the surrealists. Death of Marcel Duchamp. Some new surrealist painters come forward (Gerber, Giovanna, Sánchez, Tovar).

1969. In *Le Quatrième Chant*, published in *Le Monde*, October 4, Schuster announces the end of surrealism 'as an organized movement'. He adds: 'Does this spell the death of surrealism? No... For some, we undertake to invent the variable, which will succeed *historic* surrealism'. Shortly afterwards appears Number 1 of *Coupure*, directed by Philippe Audoin, C. Courtot, J.-M. Goutier, Legrand, J. Pierre, Schuster, Silbermann. Some young writers come on the scene: H. Baatsch, J.-C. Bailly, J.-F. Bory, P. Peuchmaurd. The 'Old Guard' regroup round V. Bounoure.

1970. Ragnar von Holten organizes the exhibition 'Surrealism?' at the Moderna Museet, Stockholm. Number 4 of *Coupure*, reproducing articles that caused the confiscation of the Maoist publication 'The People's Cause' results in a prosecution.

1971. J. Pierre organizes the exhibition 'The Spirit of Surrealism' at the Galerie Baukunst, Cologne. A fine of 1000 francs is imposed on Schuster and the publisher Losfeld in connection with *Coupure*, Number 4.

1972. The friends of *Coupure* suggest the 'visionary' Laszlo Toth, who wilfully damaged the Michelangelo *Pietà* in St. Peter's, Rome, as candidate for the 'grand prix' for sculpture and the section 'behaviour'—at the Venice Biennale.

AUTHOR'S NOTE

It was impossible within the limits of this work to take account of all those who, in the course of half a century, have made an important contribution to the surrealist movement; still less to do justice to the many artists who, from Brancusi to Rauschenberg, have taken part in surrealist exhibitions without engaging in the activities of the movement. In a small minority of cases, such as those of Alechinsky and Ponge, participation in these activities has not appeared to be an essential expression of their personality.

DICTIONARY

Age d'or (L'). `L'Age d'or` remains to this day the only attempt to exalt total love such as I envisage it,' wrote André Breton in *L'Amour fou* concerning the only truly surrealist film. Buñuel's film, produced in 1930 (Dali's share is very much less than in *Un Chien andalou*) describes in lyrical terms the communion established between two lovers, despite being parted and subjected to various forms of social repression. The impassioned violence of the dialogue is served by a revolutionary utilization, rarely equalled, of the poetic potential of the cinema (dissociation of sound from image, suppression of direct erotic image, metaphors, collages, etc.). On 3 December 1930, the League of Patriots and the Anti-semitic League ransacked Studio 28 where the film had been showing for two months. The Prefect of Police, Chiappe, decided to ban the film and his interdiction is still in force.

Alchemy. The preponderant rôle of metaphor in surrealist poetry can be compared to the symbolism used by the alchemists to designate the substances or operations of their art

Buñuel and Dali. `I had been expecting this moment for so long a time!' Shot from `L'Age d'or'. 1930.

('Scaly dragon', 'Green lion', 'Winged serpent'). In both cases reference is to an analogous thought which establishes *'correspondances'*, in the Baudelairean sense, between things, or between thoughts, or again between thoughts and things. Alchemy, directing its efforts towards the production of the 'philosopher's stone' seems eager to exploit these *'correspondances'* so as to produce a palpable effect on the physical world and bring about transformations. But perhaps alchemy, in its fullest sense, is merely the figurative description of a spiritual operation reserved for 'sages' (the hermetic Philosophers)? If so, we must understand the alchemy of the 'word' as it was transmitted from Rimbaud to the surrealists in that sense, since it is a question—through recourse to the most efficacious poetry—of 'transforming life'—a spiritual metamorphosis which would not fail to produce material consequences and akin to the visual alchemy at work in surrealist painting.

America. Strictly speaking there are no surrealist territories in the Old Continent, and the surrealist world is divided into two parts, America and Oceania (q.v.). It is of course Indian America above all which claims our attention. If the funereal splendour of the Mexican and Peruvian civilizations has profoundly affected surrealist poets and painters, it is in a different way from the influence exercised by civilizations that still survive or are not too physically remote. Among the latter, British Columbia (Haïda, Kwakiutl) occupy a privileged place

because of the prodigality responsible for the profusion of 'potlatchs', the erection of superb totems and the 'automatist' authority with which the subject of the rapidly executed drawings—exploiting formal analogies—is adapted to the available surface. The same applies to the *Pueblos* (Hopis, Zuñis, Navajos) whose 'Katchinas' dolls and paintings on sand guarantee the survival of fundamental cosmogonies. Finally, the place held by dreams in the lives of the Prairie Indians and in the activity of their 'shamans', reflected by the spatial treatment of their pictograms, could not leave the surrealists indifferent. And the surrealist example played its part in teaching U.S.A. artists, from Hare to Jackson Pollock, to examine the art of the Indians at the same time as automatism invited them to discover their own originality. In the whole of Latin America, not only the artists but also the poets and novelists felt the impact of surrealism. Furthermore, the surrealists were not grudging in their admiration of the art of the Alaskan Eskimoes for their fresh and telling symbolism, nor to the rites of Haitian Voodoo, that strange offshoot of African beliefs.

Amour fou ('Unique, total love'). How can we foil the conspiracy of those obscure forces that oppose the realisation of our desires? Perhaps only if we give sufficient confidence to those desires, and also provided that they are illuminated in the last resort by the sole light of elective love which brings each individual in the course of his life into contact with another human

American Indian art
(Kwakiutl).
Articulated mask
in painted wood.
1850-1900. Museum
of the American
Indian, New York.

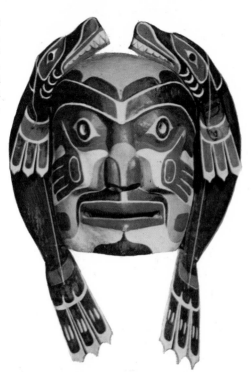

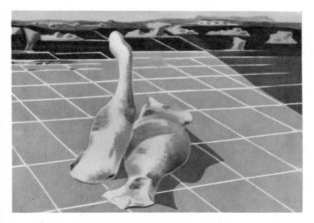

Paul Nash.
Painting.
1936.
Private
collection.
See p. 63.

being and one only. Then only can life fulfil a more or less secret desire, as Breton notes in this book (published in 1937) when he tells about *'la nuit du tournesol'* ('the night of the sunflower') when, through the encounter with the woman who was destined to become his wife, the prophesy, made eleven years before in one of his poems was fulfilled; or again, in the case of the 'discovery'—like that of Giacometti discovering in a junk shop the object which was to enable him to complete his sculpture *The Invisible Object*. Breton s reflection on love was continued in *Arcane 17* (1945).

Apollinaire Wilhelm Apollinaris de Kostrowitzky, *called* Guillaume (Rome 1880—Paris 1918). *'C'est bien plus drôle quand ça change—Suffit de s'en apercevoir'* ('It is much more droll when things change—It suffices to become aware of it'). In opening poetry up to the demands of modern life, making it aware of the ruptures occurring in avant-garde art, while at the same time lending an attentive ear to the erotic and the esoteric, Apollinaire was the immediate precursor of surrealism, unmethodical and sometimes wayward, but for the most part a precursor of genius.

Aragon Louis (Paris 1897). 'Always pure rainbow...' (André Breton). A dazzling mountebank, prose-writer of distinction, indefatigable poet, he held the second place in surrealism from its origins to the fateful year 1932 when he delivered himself up soul and body to the French Communist Party which used him as the neon light of its

cultural politics. If the verse collections of his surrealist period can be considered (like those which followed) as null and void, it is a different matter for the prose which sparkles with such brilliant fireworks as: *Anicet or the Panorama* (1921), *Libertinage* (1924), *The Peasant of Paris* (1926), *Treatise on Style* (1928), *Painting defiant* (1930). Having become the leading French advocate of 'social realism', cheerfully worshipping what he had once committed to the flames, he was converted into a realist novelist from the time of his *Bells of Basel* (1933) and from *Crève-Cœur* (1941) into a flag-wagging poet of patriotic, military and conjugal virtues *(Les Yeux d'Elsa)* in 1942. Since 1966, he claims to be in communication with the spirit of André Breton, without, however, having attempted to sever the flowery chain by which the Party holds him and which, in his own words, 'has given the colours of France' back to him.

Arp Hans *or* Jean (Strasburg 1887—Basel 1966). 'I sleep and I wait for the leaves to grow': is not one tempted to say that Arp owes everything to sleep? Sleep, or rather dreams, for it is the hallucinatory character of his inspiration which, from 1916 onwards, distinguishes him from the other participants in Dadaist activities in Zurich and was to persuade him alone among them to rejoin the surrealist ranks in 1925. Thanks to his automatism, consisting of short, nervous lines and stains with fluid contours, he appears to have discovered once and for all the complete repertory of

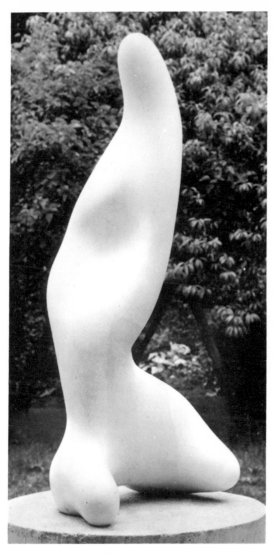

Arp. Cobra-Centaur. 1952. White marble.

forms capable of expressing an inward life of great richness. Hence the amazing and exceptional continuity of his work which in the course of a half-century of uninterrupted invention has never suffered any break. The predominating form in Arp is a kind of malicious bean whose wide-open eye indicates the hope for life and the promise of a future but mysterious development, since the embryonic state this suggests is common to man, bird and fish. It is, however, only right that we should take into account a constant temptation since 1914 which is manifested in his recourse to geometry and would seem to be the static counterpart, directed towards the death of the dynamic and burgeoning celebration of life. Fortified by the presence at his side by his wife, Sophie Taeuber (1889-1943), an excellent abstract painter, this temptation has led the artist to combine participation in exhibitions of abstract art with surrealist activities at a period (c. 1930), however, when abstraction and surrealism were at daggers drawn. But Arp's poetry, among the most spirited (in German as in French) of the twentieth century, with its note of lively mockery and sense of the 'marvellous' which emanates from it, reassures us that the essential inspiration is omnipresent—the 'pure psychic automatism' which Breton in 1924 defined as the essence of surrealism. Almost the whole corpus was collected up in 1966 by Marcel Jean, under the title *Jours effeuillés:* it is one of the great books of our time; between its pages were interleaved, first in 1916, the biomorphic wood-

engravings, the *papiers collés* 'according to the law of chance' and the first cut-out wood blocks, then in 1930, the first 'concretions' (sculptures), string-pictures and the first *'papiers déchirés'* in which from the ruins of a torn drawing grace and beauty still surge. 'The *papier déchiré* is beautiful and perfect like nature. Birth and disappearance are natural to it and there is no tragedy.' Thus, Arp would seem to suggest that life and death form an endless chain.

Artaud Antonin (Marseille 1896–Ivry-sur-Seine 1948). 'Youth will always recognize this burnt-out oriflamme as its own' (A. Breton). It has become a commonplace to oppose Artaud to surrealism in general and to Breton in particular. It is certainly true that there is no confusing Artaud with anyone else, above all when, during his final years, he achieves a permanent 'poetic frenzy' in accents never before heard. But this state of melancholy tension was already present—if in a lesser degree—when he directed the Bureau of Surrealist Enquiries in 1925 and impressed his own corrosive fever on various manifestoes *(Address to the Dalaï-Lama, Address to the Pope, Letter to doctors in charge of asylums).* It is true that Breton was opposed to the hysterical reaction which these provoked just as Artaud was opposed to the preoccupations which then drove Breton and several other surrealists in the direction of communism. The rupture occurred following the foundation of the Théâtre Alfred Jarry in 1926 by Artaud and Vitrac. For ten years

Arp. Configuration. 1928.
Kunstmuseum, Basel.

Arp. The Man with
three navels. 1920.
Private collection,
Meriden.

the theatre and cinema monopolized Artaud, who put his vibrant sensibility and his remarkable features at their disposal. In Mexico, in 1936, he was deeply impressed by the 'peyotl*' dance performed by the Tarahumaras Indians, and it was during his voyage home that he gave evidence of a derangement which caused him to be taken off to a mental institution on his disembarcation at Le Havre in 1937. After being under the care of Dr Ferdière at Rodez, he was discharged in 1946 and then published his finest works (*Van Gogh, Society's suicide*, 1947). And his *Theatre of Cruelty* (1932) has never ceased to stimulate avant-garde producers.

Art brut. This term, invented by the painter Jean Dubuffet c. 1948, in contradistinction to 'cultural art', designates the artistic creations of the self-taught, isolated—for social reasons or through individual circumstances—from ordinary cultural activities and places where resulting artifacts are displayed (art schools, galleries, museums). '*Art brut*', henceforward no longer the product of a social rite but of a strictly individual impulse, is characterized by a kind of spontaneous generation, since the artist derives the total substance of his work from his own imaginative experience. The question is the degree to which this kind of artist approximates in the process to the surrealist painter or sculptor who by recourse to automatism or the most banal figurative

* *Mexican cactus. Its consumption induces visual hallucinations.*

code (e.g. Magritte), aspires to a 'similar state of grace'. This convergence seems less surprising if we emphasize the number of 'medium-painters' in the ranks of '*Art brut*' who draw or paint on the 'automatic' principle. But the largest proportion is represented by painters suffering from mental derangement, among whom the schizophrenics make up the strongest and most glorious contingent. The study of schizophrenic art has high-lighted some general characteristics (use of *bourrage*, the stereotype, etc.) which should be compared with similar phenomena in the automatism of mediums and surrealists. The third category of '*Art brut*' comprises self-taught artists who depend neither on psychiatry nor spiritualism, although their works have affinities with those of the other two categories. The surrealists, and Breton first and foremost, have been anxious to show that they regard them all—mediums (Joseph Crépin, Ferdinand Cheval, Augustin Lesage), schizophrenics (Aloïse, Adolf Wölfli) and autodidacts (Gaston Chaissac, Robert Tatin, Scottie Wilson) as exemplary creators.

Ascendant sign. According to Breton the sense that links the two terms of the metaphor can only be 'ascendant'. 'From the first of these realities to the second, it (the metaphor) marks a vital tension directed in the highest possible degree towards health, pleasure, tranquillity, grace, accepted customs. Its mortal enemies are the depreciatory and the depressing'. He backs this up with a Zen fable: Out of Buddhist kindness

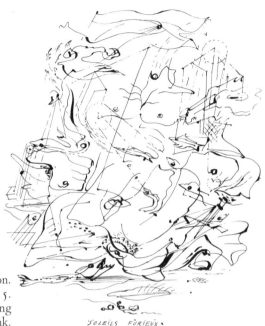

André Masson.
Furious Suns. 1925.
Automatic drawing
in pen and ink.

SOLEILS FURIEUX

Basho ingeniously modified a cruel *'haïkaï,'* composed by his humorous disciple, Kikaku. The latter said 'A red dragonfly—pull off its wings—a pimento'. Basho substituted 'A pimento—put wings on it—a red dragonfly'.

Automatic writing. The expression is borrowed from spiritism, indicating whatever the mediums write in a trance at the dictation of the 'spirits'. But when Breton, in 1919, describes a writing so rapid that it eludes the various controls of reflexion, logic and the proprieties, he has in mind Rimbaud's verbal alchemy and Lautréamont's frenzied rhetoric and other examples of narrower range, but no less effective, such as Apollinaire's *Onirocritique* (1908). He also has in mind the spontaneous confession which the patient on the psychoanalyst's couch is invited to make. 'Put yourself in the most passive or receptive state possible. Strip yourself of your genius, your talents and those of everyone else. Tell yourself that literature is one of the most dismal roads that lead to anything and everything. Write quickly without preconceived subject, quickly enough not to hold back and be tempted to

23

reread what you have written (Breton, *Surrealist Manifesto*). *The Magnetic Fields* opens a way which is relatively free from obstruction even to the present day, although Breton often felt impelled to denounce the concessions made by the poets to literary vanity as the major obstacle to the purity of automatic outpourings.

Automatism (in the plastic arts). The Canadian 'automatists' distinguish between three types of automatisms: 1. *mechanical* automatism, the result of 'strictly physical processes; *plissage* (paper crinkling), *grattage* (scraping), *frottages* (rubbings), deposits, *fumage**, gravitation, rotation, etc.' 2. *psychic* automatism, based on the recollection of dreams (Dali), hallucinations (Tanguy), 'chances of all kinds' (Duchamp): 'interest centres more on the subject treated (idea, resemblance, image, unforeseen association of objects, mental relation) than on the actual subject (plastic object, dependent on the expressivity of the substance employed).' 3. *superrational* automatism, impromptu plastic writing: one form invokes another until a sense of unity is arrived at or until one can proceed no further without destroying the artifact. During the process, no attention is paid to 'content'. The assurance that it is unescapably held in the 'container' justifies this liberty...' (1948). What Breton in 1939 called 'absolute automatism' apropos Dominguez, Paalen, Matta, corresponded to the

* *Smoke-trails made by a candle flame on the surface of a picture.*

'superrational' kind, the difference being that the surrealists generally reserve the right to interpret the results of automatism, in short to *read* them; whereas the 'automatists' and the lyrical abstracts (or abstract expressionists) usually reject this interpretation. The latter, on the other hand, have no objection to doing some retouching, on aesthetic grounds, to preserve the harmony of the picture.

Baron Jacques (Paris 1905). 'Boxers and girls in vests stand with their arms encircling each other on a piece of waste ground.' He is sixteen years old when he joins Breton and his friends. A graceful poet (*L'Allure poétique* 1924), he published his memoirs '*L'An I du surréalisme*' in 1969.

Bataille Georges (Billom, Puy-de-Dôme 1897—Paris 1962). In a wild and fiery book *Histoire de l'œil*, Bataille introduced thoughts on the relations between pleasure and death, which end only with Bataille himself. Very close to surrealism, but in open conflict with it because Christianity and suffering held a particular fascination for him, Bataille emerges finally as the inseparable negative of Breton: 'We can consider André Breton and Georges Bataille as the two poles of the surrealist spirit such as it has been manifested up to the present' (Patrick Waldberg). About 1930, after rallying those members of the surrealist movement from whom Breton had just parted company, Bataille cofounded with the latter in 1935 the anti-

fascist group *'Contre-Attaque'*. Further rifts appear, but just after World War II, both men, while still maintaining their differences, continue to demonstrate the esteem in which they held each other. Among Bataille's major works, mention should be made of the erotic tales: *Madame Edwarda* (1941) and *Ma Mère* (1966), the essays *La Part maudite* (1949) and *L'Erotisme* (1957).

Belgium. In 1924, Camille Goemans (1900-1960), Marcel Lecomte (1900-1966) and Paul Nougé (1895-1967) founded the group and the review *Correspondance*. In 1925, Magritte and Mesens published the review *Œsophage*. From the union of these two groups—despite quarrels and expulsions—surrealist activity of considerable homogeneity results, with common ground in the work of Magritte. André Souris (1898-1970), Louis Scutenaire (b.1905), Paul Colinet (1898-1957) and Marcel Mariën (b.1920) appear successively on the scene and take their place in the midst of this activity which finds an outlet in new reviews (*Marie*, *Variétés*, *Documents 34*, etc.), booklets of poems and exhibitions. The distinctive mark of Brussels surrealism is the apparent modesty of its ambitions and a certain neutrality of tone; no hint of surrender to lyrical outbursts or indulgence in exaggerated exhibitionism. They talk confidentially in a subdued atmosphere in which the words and objects of everyday life suddenly acquire an unaccustomed resonance; an unobtrusive manner is cultivated

which all at once gives way to an unequivocal spirit of mischief. This pseudo-unctuous line, and the sometimes earthy humour it implies, caused variations of temperature— sometimes distinctly chilly—between Brussels and Paris, as, for example, in 1946 at the time of a temporary adherence to Stalinism on the part of Magritte and his friends. In this group, after Magritte, Nougé is the outstanding figure and the one who most threatens to pass the bounds of its affected prosaicness (*Quelques écrits et dessins de Clarisse Juranville*, 1927; *René Magritte ou les Images défendues*, 1943; *L'Expérience continue*, 1966). Colinet, Lecomte, Mesens and Scutenaire are poets and occasional humorists; Goemans ran the Galerie Surréaliste in Paris, Mariën published his friends' works, Souris defied the surrealist ban on music. Magritte's influence was and remained considerable, to the point of interfering with the rise of other valid surrealist painters in Belgium, with the possible exception of Jane Graverol (b.1910). The case is different for Paul Delvaux (b.1897) who never really took part in surrealist activities. Away from the Brussels surrealists, Achille Chavée (1906-1969), who founded the surrealist group of La Louvière in 1935, lived for poetry.

Bellmer Hans (Katowice 1902). Bellmer begins to construct his 'Doll' in 1932 in Berlin under the influence of three stimuli: the rediscovery of his childhood treasures, the ambiguous charm of a little cousin, Ursula, and the performance of Offenbach's *Tales of Hoffmann*.

The photos of the doll came into the hands of the surrealists who published them in *Minotaure* in December 1935, under the title 'Variations on the assembling of an articulated minor'. Bellmer produces an improved second version of his attractive Lolita and, in 1938, arrives in Paris where he participates in surrealist activities. Eluard writes staggering commentaries for the *Doll*. First interned by the French, then 'wanted' by the Germans, Bellmer had a tough time during the war years. However, thanks to his tremendous graphic virtuosity, he has been able to put his engraving talent in the service of this total permutability of the parts of the female body of which he dreams and which has never ceased to haunt him (*Anatomie de l'image*, 1957). All the evidence points to Hans Bellmer as being a 'polymorphous pervert'.

Benoît Jean (Quebec 1922). In Paris, 1949, he undertook a strange enterprise called *The Execution of the Testament of the Marquis de Sade* which kept him busy for two years. It is a very complicated costume, made up of superimposed coverings and accompanied by important accessories. Each element of the ensemble (medallion, tights, crutches, panels, mask, boots, wings, tomb, push-chair, *membrum virile*, codpiece, chastity-belt, with tattooing thrown in) transposes some aspect of Sadian thought into plastic terms. The work was to be worn during a special ceremony which took place December 2, 1959, at Joyce Mansour's, the evening preceding the Interna-

tional Exhibition of Surrealism ('Eros') in Galerie Daniel Cordier. In 1965 Benoît completed another work for carrying round as a tribute to sergeant Bertrand, a famous nineteenth-century necrophile, *The Necrophile*, and a sculpture *The Bulldog of Maldoror* which he presented at the international surrealist exhibition '*L'Ecart absolu*', Galerie L'Œil, in the same year, 1965.

Brauner Victor (Pietra Naemtz, Rumania, 1903—Paris 1966). On 27 August 1938, in the course of an argument, Dominguez throws a glass at Esteban Francès and Brauner, who interposed his body, lost his left eye as a result. Strangely, the theme of the torn-out or blinded eye had occurred insistently in several canvases, particularly in 1931 and 1937. This accident also caused a perceptible change of direction in his work; convinced that he can now catch secret messages or foil plots of occult forces, Brauner first devotes himself to the evocation of attractive female ghosts (the 'Chimera' series, 1939-1940) before undertaking the construction of a magic universe based on the permanent conflict between the artist and his 'demons'. Among his wax paintings, those of 1945-1947 recreate in splendid 'frozen' colours the hieratism of the frescoes of Precolumbian Mexico and their exciting bestiary. If, on occasion, a kind of internal seething bursts through this formal ceremonial, Brauner does not fail to return to these somewhat stilted compositions that emanate from his basic aggressiveness.

Bellmer. Machine-gun in a state of grace. 1937.
Wood and metal. Museum of Modern Art, New York.

Magritte. Philosophy in the boudoir. 1947.
Thomas Claburn Jones Collection, New York.

Jean Benoît.
The Necrophile
(dedicated to
Sergeant
Bertrand).
1964-1965.
Being-object.

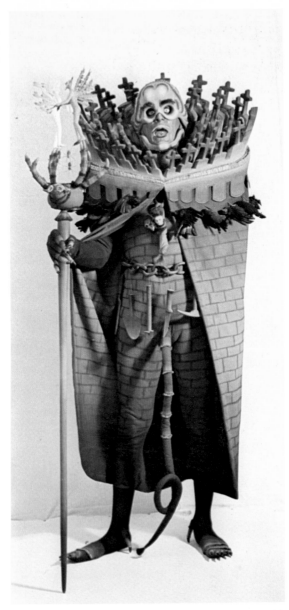

Breton André (Tinchebray 1896–Paris 1966). The life and work of André Breton is inseparable from surrealism, every manifestation of which, without exception, he made his own. We owe it, in fact, to Breton's theories and his practical demands that surrealism has been enriched with countless contributions—which would have seemed contradictory to a more timid spirit—and has thus become the anti-systematic system, constantly subjected to the test of facts. It is to this that Breton owes his incomparable influence which arises from his exceptional affective and intellectual endowments. It shows itself, to start with, in his extreme impatience—from childhood on—with every form of discipline that society metes out through the intermediary of school and family. Without this basic attitude of revolt which never deserts him for a moment, Breton would be incomprehensible. It led him to accept modalities of expression which escape individual or collective controls (automatism) just as social revolution appeared indispensable to bring a restraining social order on earth. The accent is put once and for all on the most explosive ferments because they are most opposed to the conventions that control society to the detriment of man's fundamental needs: 'amour fou' because it stands opposed to these two symmetric devaluations represented by Christian marriage and libertinage; liberty 'colour of man,' because nothing worthwhile can justify its renunciation, even for the benefit of hypothetical 'exulting tomorrows', poetry, finally, since it is the true language, undisfigured by the everyday wear and tear of words and the only one capable of allowing sensitive communication between men and a close understanding of the world. Breton's steadfast adherence to this triple imperative enables us to comprehend his attitude in all the crises which the surrealist movement has undergone and on the occasion of serious ruptures. What has so often been described as inhuman severity appears then rather as the sign of that ineradicable hope that the world and life can be transformed. As for the odious tyrant image, regularly denounced by certain re-

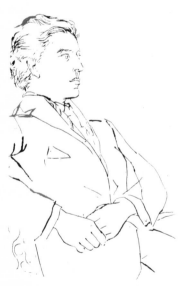

Picasso. Portrait of A. Breton. Pen and ink drawing.

A. Breton. Poem-object. Roland Penrose collection, London.

jected malcontents, it hides, in fact, that of a man strangely in love with people and their real truth. Failure to understand this means failure to appreciate the undiminished power of attraction that Breton exercised over youth for half a century. Side by side with these works essential to a proper understanding of surrealism, the *Manifestoes* on the one hand and on the other *Nadja* (1928), *Communicating Vessels* (1932), *L'Amour fou* (1937) and *Arcane 17* (1945), we should look at his poetic work (*Clair de terre*, 1923; *Poisson soluble*, 1924; *Le Revolver à cheveux blancs*, 1932; *L'Air de l'eau*, 1934; *Les Etats Généraux*, 1943; *L'Ode à Charles Fourier*, 1947; *Constellations*, 1959), masterpieces of limpidity.

Brignoni Serge (Chiasso, Switzerland, 1903). A friend of Paalen, Giacometti, Hayter, his association with the surrealists dates from 1929. His most valuable contribution consists in his attempt to assimilate the lyrical and plastic inspiration of the Pacific Islands, the favoured source of surrealist art, into Western sculpture. Seen in this light, his wood-carvings of 1933-1934, anticipating Stahly's work by ten years, deserve a place of honour, so far denied him, in the relation between surrealism and sculpture.

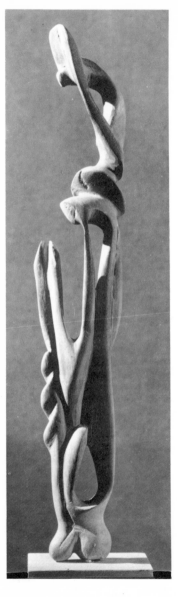

Brunius Jacques-B. (Paris 1906–
London 1967). 'There was once a
dizzy skylark who had not contrived
to save a single sou.' Brunius was
no more successful than the bird in
amassing money. With no thought
for the morrow nor of glory, he
freely scattered his poems, films,
collages, translations and finally
incisive studies on *Vathek* and
Alice in Wonderland to the winds.

Buñuel Luis (Calanda, Spain,
1900). The education he received
from the Jesuits should certainly be
mentioned. At the University of
Madrid he meets Dali with whom,
in 1929, he makes his first film, *Un
Chien andalou*. After which, both
join the surrealists to whom they
offer that gem, the film *L'Age d'or*
(1930), made possible only thanks
to the patronage of Vicomte de
Noailles. Despite this brilliant start,
Buñuel had to fight step by step for
his place in the sun; first, by a series
of Mexican commercial films among
which *Los Olvidados* (1950) is out-
standing. Henceforward, in succes-
sive films and in an apparently
detached mood, Buñuel has been
content to express the permanent
pressure of desires in everyday life
and the osmosis which exists between
dreams and reality, and in such works
as *El* (1953), *Nazarin* (1959), *Viri-
diana* (1961), *L'Ange extermina-
teur* (1962) and *Le Charme discret
de la bourgeoisie* (1972), to establish
himself as one of the greatest film-
makers. *His* imprecations are purer

Brignoni. Plant. 1937. Wood.

than the hymns of the Christian church', wrote Henry Miller apropos *L'Age d'or*.

Cabanel Guy (Béziers 1926). 'L'Artisan secrète les voies de l'ébullition, en discourant sous les cyprès, en dérobant les joies métalliques. L'orchestre est au fond du puits.' ('The artisan secretes the ways of turmoil as he discourses under the cypresses, stripping off metallic joys. The orchestra is at the bottom of the well.') From *A l'animal noir* (1958), his first work, Cabanel's poetry impresses by its pulsating hermeticism in which a process of verbal telescoping evokes ecstatic and sensual landscapes.

Cafés. Paris cafés, from *Cyrano* or the *Certà* of the 'heroic' period to *La Promenade de Vénus*, the last that Breton frequented, have held a favoured place in the surrealist movement. Between the wars, the surrealists could be found in them, midday and evenings, and were thus enabled to deal with the permanent disposition of forces their movement required. The surrealist cafés are in no sense 'literary' cafés; all exchanges of information and commentary, indulgence in surrealist 'games', the reading aloud of texts, welcome of new members, quarrels, etc., have to take place in the setting of a genuine café with the comings and goings of its habi-

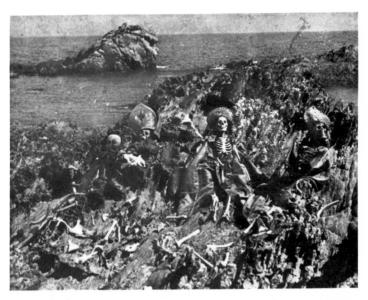

Buñuel and Dali. Skeletons of bishops. Shot from 'L'Age d'or'. 1930.

tués, lovers and players of belote. Naturally the esteem in which drinks—preferably alcoholic—in general are held is a factor. Likewise the relation between the café and the quarter—usually chosen from those which the surrealists consider particularly inspiring.

Caillois Roger (Rheims 1913). There are two men inside Caillois— the one suspects alarming anomalies in the universe of natural forms and human customs, the other cleverly exploits rationalist trappings to cloak the anxiety raised by such hypotheses. The former participates in surrealism from 1932 to 1939, encouraging the increasing interest in myths shown by the movement. The latter was elected to the French Academy in 1972.

Calder Alexander (Philadelphia 1898). It is not impossible that the notion of symbolic function which inspired the appearance in 1932 of Calder's first mobiles had its origin in Dali's 'surrealist objects with symbolic function' (1931). It is at any rate evident that these mobiles, at least the best examples, are pictures by Arp and Miró which have suddenly sprouted wings. They are 'Calders' nevertheless and the man whom Prévert calls 'the giant with a fairy's fingers' has peopled the enchanted forest of surrealism with those iron birds which never alight and which sing in colours.

Camacho Jorge (Havana 1934). Up to 1966 Camacho gives us descriptions of sordid slaughter in dark corners or relates the maladies of sanguinary tyrants or of purulent ascetics; and from this clinical picture deduces the horror of living. These excoriated subjects are succeeded in 1967 by rebuses in which cruelty is frozen in a kind of parade, as if it renounced living, in order to develop more effectively the story of what it had been. Everything now happens in the glimmers of dawn.

Canada. It is in Gaspésie, near Quebec, that Breton in 1944 writes *Arcane 17* and hears the news of the liberation of Paris. But he does not then make contact with the 'automatist' group formed round Paul-Emile Borduas (1905-1960) who from 1941 on, set emancipation by automatism against the decorative mannerism of Alfred Pellan (b.1906), also influenced by surrealism. Borduas, Marcel Barbeau (b.1925), Marcelle Ferron (b.1924), Pierre Gauvreau (b.1922), Fernand Leduc (b.1916, Jean-Paul Mousseau (b.1927), Jean-Paul Riopelle (b.1923), however, succumb more or less happily to the 'automatist' fever. In 1948, the publication of *Refus global*, an extremely violent text, marks the climax of the collective action of the 'automatists' and rifts appear in the group when Borduas accuses the surrealists of remaining faithful to onirism. Riopelle alone takes part in the surrealist activities in Paris from 1947 to 1950. In 1953, Borduas himself turns away from automatism. From 1959 on, Pellan's pupils Jean Benoît and Mimi Parent involve themselves in surrealist activities.

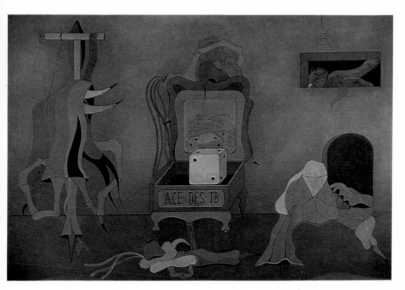

Camacho. Ace Des Tr... 1967. Private collection, Paris.

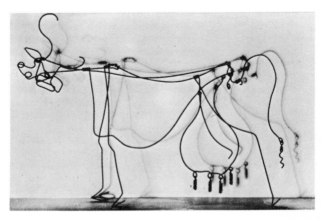

Calder. Cow. Wire. Museum of Fine Arts, Boston.

Canary islands. In 1931 a surrealist centre develops in the Canary Islands around the review *Gaceta de Arte* under its director Eduardo Westerdahl: other contributors are the poets Domingo Pérez Minik, Domingo Lopez Torres, Pedro Garcia Cabrera, Agustin Espinoza and the painter Oscar Dominguez. The arrival of Dominguez in Paris and his adherence to the surrealists (1934) facilitate contacts. In 1935, the *Gaceta de Arte* organizes an international surrealist exhibition at Santa Cruz in Tenerife and invites Breton and Péret to the Canaries for the occasion. In 1936 the Governor of the Canaries, General Franco, assumes the leadership of the rebellion against the Spanish Republic. Minik and Torres are executed. Cabrera is deported to Rio de Oro; Dominguez alone manages to flee and regain France.

Cárdenas Agustin (Matanzas, Cuba, 1927). Cárdenas liberates himself from an 'exterior model' by recourse to semi-automatist drawing around 1951, just as he liberates himself from academic naturalism by trying to realize his drawings in three-dimensional terms. Thus, by the time he leaves his native island for Paris where he is to carry out his work, he is already (1955) able to make sculpture into a repository for his most intimate desires and deepest nostalgia. The surrealists who welcome him in 1956 and invite him to all their group exhibitions had every reason to congratulate themselves. At the meeting-place of the remote African tradition (Cárdenas is a coloured West-Indian) and the lyrical revolution introduced by Brancusi and Arp, Cárdenas' work represents one of the most harmonious, as well as the most profoundly meaningful contributions to twentieth-century sculpture.

Carrington Leonora (London 1917). 'I saw her wave her hand above the balustrade, and while she was waving it, her fingers became detached and fell to the ground like shooting-stars.' From her first stories (*The Oval Lady*, 1939) and her first pictures, Leonora Carrington revealed herself as the chatelaine of a domain where ghosts bestride wooden hobby-horses, where goats hatch the alchemic egg, where hyenas attend the ball and white rabbits feed on human flesh. This domain is transported in turn, as if by magic, from London to Saint-Martin in Ardèche (where the feudal lord was called Max Ernst), from there to a clinic in Santander, then to New York, and finally to Mexico.

Césaire Aimé (Basse-Pointe, Martinique, 1913). 'We claim kinship with the *dementia praecox* of the flaming madness of tenacious cannibalism.' Breton meets him in Martinique in 1941 at the time when Césaire has already published his admirable *Cahier d'un retour au pays natal*. Thereafter Césaire participates in surrealist activities, and when in 1945 he is elected communist deputy of Martinique, Breton and his friends give a banquet in his honour in New York. His torrent of poetry, with its dazzling images, preserves Césaire, whose main concern is the emancipation of the

natives of Martinique, from the intellectual suffocation of the French Communist Party which he leaves in 1956. Meantime, through his poetry and his *Discourse on Colonialism* (1951) he became the herald of African independence, a preoccupation which was a natural prelude to his most didactic play (*A Season in the Congo*, 1967).

Char René (L'Isle-sur-Sorgue 1907). '*Dans les nacelles de l'enclume—Vit le poète solitaire—Grande brouette des marécages.*' ('In the nacelles of the anvil—Lives the solitary poet—Large wheel-barrow of the marshes.') Char made his first surrealist collections of verse under the transparent title *The Hammer without a master* (1934). In 1948 the 'master' picked up his hammer again and, as one might expect, this time attributed the merits of his instrument to himself (*Fureur et Mystère*).

Chicago. The most characteristic current of artistic life in Chicago is resolutely oniric, often erotic and humorous into the bargain, to the point of lapsing into a kind of fantastic satire. George Cohen, Leon Golub, Irving Petlin and Seymour Rosofsky are initially the most representative of this current. Inspired by the Californian poet, Peter Saul, but likewise influenced by the 'comix' of Crumb and Shelton or the example set by '*Art brut*,' Jim Nutt, Gladys Nilsson,

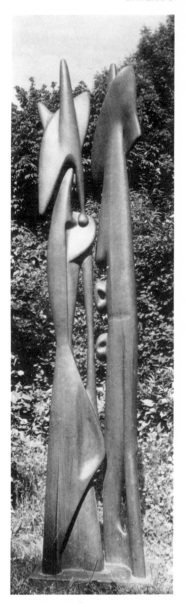

Cárdenas.
West Indian couple.
1957. Mahogany.

37

Ed Paschke, Kerig Pope, Barbara Rossi, Christina Ramberg and Karl Wirsum have for some time been developing a wayward and coloured imagery; Roger Brown is a 'primitive' with hints of de Chirico, Jordan Davies an abstract 'automatist'. As for H.C. Westermann, his sculpture is as oniric as Giacometti's of 1929-1935. Since 1960 the driving forces behind surrealist activity have been Franklin and Penelope Rosemont.

Chile. Braulio Arenas (b.1913), Jorge Cáceres (1923-1949) and Enrique Gómez Correa are the main activists of surrealism in Chile, marked successively by the founding of the review *Mandragora* (1938), a surrealist exhibition (1941), the founding of the review *Leitmotiv* (1942), finally an international exhibition of surrealism (1948). But the most famous Chilean surrealist, Matta, did not participate.

Collage. Surrealist collage technique as practised and perfected by Max Ernst from 1919 is based on two different methods: either an engraving (of a machine for example) suggests a complementary theme that the artist adds in pen or brush; or else the final picture results from the combination of several parts cut out from different engravings. In either case the artist's will imposes his sovereign law on one or several pre-existing images. Thus, the collage can be considered either from the narrow technical angle, or the broader poetic or even philosophic aspect which consists in exploiting the known to discover the unknown. The adoption of pre-existing elements

Max Ernst.
L'immaculée conception.
1929. Collage for
'La Femme 100 Têtes'.
Private collection, Paris.

Carrington. Lepidoptherus. 1969. Galeria de Arte Mexicano, Mexico City.

Max Ernst. Loplop and 'la Belle Jardinière'. 1929.
Collage for 'La Femme 100 Têtes' (roman-collage).

(engravings or photographs, even academic 'daubs') enables the artist to insert the collage in an extension of the cubist *papiers collés* technique and the 'readymades' of Duchamp; likewise in 'verbal collages', used particularly by Lautréamont (encyclopedia descriptions introduced into the development of the narration). Furthermore, Ernst stated that he invented collage after seeing reproductions of de Chirico paintings. It can be considered as a method for making up for the absence or inadequacy of the artist's *'visions'*. The collage principle, whether in painting or sculpture, holds a front-rank place in contemporary art.

Communicating vessels (The).

'The future poet will overcome the depressing notion of the irreparable divorce between action and dreams.' In this book (published in 1932) which is the diary of a particularly critical period for him when he comes close to despair, Breton considers the hallucinatory and affective life from day to day, side by side with psycho-analysis on the one hand and Marxism on the other. In spite of the considerable obstacles encountered en route, he confirms in this work the fundamental communication afforded to us through dreams, love and revolution*.

Convulsive Beauty.

Breton's *Nadja* ended thus: 'Beauty will be convulsive or will not be,' a phrase he developed in *L'Amour fou* as follows: 'Convulsive beauty will be erotically veiled, a "frozen" explosion, materially-magical, or will not be.'

* *Cp.* Entretiens radiophoniques *(1952).* Breton *refers to the important message of this book:* 'l'échange constant qui doit se produire dans la pensée entre le monde extérieur et le monde intérieur'.

Max Ernst. The sap rises. 1929.
Collage for 'La Femme 100 Têtes'.

Cornell Joseph (New York 1903). Cornell is the first American artist to be influenced by surrealism. His discovery of *La Femme 100 têtes* by Max Ernst leads him, too, to execute collages. In 1936, it seems, he exhibits his first box, for from now on alls his works assume this form: a box, usually glazed, at the back of which are arranged objects or collages. With the help of the most modest, the most un-exciting elements (cork balls, rings, glasses, flasks, metal stalks, hotel labels, bits of engravings), Cornell contrives to create an impression of haunting melancholy, possibly the result of childhood memories (real or imagined).

Crevel René (Paris 1900—Paris 1935). 'From the bridge of death, come and see, all of you, come and see the festival that is igniting.' It was after exhausting himself in a struggle to get Breton's right to speak at the Congress of Writers for the Defence of Culture restored that Crevel gassed himself with the word 'disgusted' pinned to his lapel. He had made every effort, despite Aragon's defection, to maintain the contact between sur-realists and communists. With his absolute intellectual integrity, Crevel proved himself an effective and fierce pamphleteer (*Spirit versus Reason*, 1928; *Diderot's harpsichord*; 1932). In his novels, the agitation

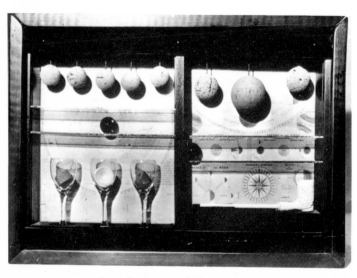

Cornell. Soap Bubble Set. 1948.
William N. Copley collection, U.S.A.

of modern towns is mingled with internal torment (*Babylon*, 1927; *Are you mad?*, 1929). But are they really novels? As Claude Courtot writes 'Crevel's work is a permanent denunciation of the literary lie.'

Czechoslovakia. Surrealism never awakened deeper and more lasting echoes than in Czechoslovakia. The intense fermentation of intellectual and artistic circles after the First World War was to be particularly manifested in 'poetism' (1923-1932), a transitional movement between cubo-futurism and surrealism, the plastic equivalent of which was to be the 'artificialism' of Styrsky and Toyen. The association *'Devetsil'* and its two animators, the theorist Karel Teige (d. 1951) and the poet Viteslav Nezval (1900-1958), were to result in 1934 in the founding of the Prague surrealist group where we find not only Teige, Nezval, Styrsky and Toyen but the sculptor Vincenc Makovsky (1900-1966), the poets Konstantin Biebl and Jindrich Honzl. The connection with Marxism is much more open there than in Paris, a fact which Breton and Eluard did not fail to observe on their trip to Prague in 1935. Nevertheless, Nezval was soon to make a move, comparable to Aragon's, towards Stalinism. The Nazi occupation did not prevent the surrealist fermentation from continuing clandestinely, around Teige (Styrsky died but then Heisler came on the scene), or in the surrealist group *Ra*: Joseph Istler (b. 1919), Ludvik Kundera, Vaclav Tikal (b.1906) or in the Sporilov group of surrealists whose outstanding

Makovsky. Woman and child. 1933. Stone and iron. National Gallery, Prague.

member was Zbynek Havlicek (1922-1969) or in Slovakia (Mikulas Bakos, etc.). The International Exhibition of Surrealism at Prague in 1947 resulted in a re-grouping around Teige of the painters Istler, Mikulas Medek (b.1926), Tikal, the poets Karel Hynek and Vratislav Effenberger. The Prague 'coup' kept Heisler and Toyen in Paris whilst it compelled the others to resort once again to under-cover activity. But no more than on the previous occasion did this interrupt

Dali. Sleep. 1937. Edward James collection, England.

the surrealist ferment, increasingly distributed, as it were, among several centres, some inclined towards 'structuralism', others towards 'existentialism', others again towards psychoanalysis. The salient feature, as in 1935, remains the close link with Marxism; it would even appear that surrealism in Czechoslovakia contributed to preserve Marxism from Stalinist corruption. Around Effenberger the 'Spring of Prague' was to bring to the fore the poets Stanislas Dvorsky, Petr Kral, Prokop Voskovec, in painting the collages by Ivo Medek and Ivana Spalangova, the abstract rhythms of Roman Erben (b.1940), the 'paranoiac' interpretations of Martin Stejskal (b.1944) and notably his 'contourages' of calendar pin-ups. But the group review *Analogon* appeared two months before the

Soviet tanks announced the third clandestinity of surrealism in Czechoslovak territory.

Dali Salvador (Figueras, Spain, 1904). 'When I look at the starry sky, I find it small. Either I am growing or the universe is shrinking. Unless it is both at the same time.' Dali's entry into surrealism between 1929 and 1938 was particularly electrifying at a time when the movement, involved in political action on the one hand, was anxious, on the other, to consolidate its inimitable character. Dali's total indifference to social concerns was, from 1934, to give way to the expression of more and more flagrantly reactionary nostalgia (eulogy of the monarchy, race, the Church, the academic 'profession,' etc.). Nevertheless, his example was an indisput-

able contribution to the maintenance of the revolutionary virtues and the affirmation of the individual desire as a motive of moral subversion. For his part, Dali discovered in surrealism every element capable of enhancing his individual genius and even transforming what was more often than not inglorious eccentricity into piquant singularity. A perfect knowledge of psycho-analysis, used to cultivate these eccentricities rather than to attempt to cure them, plays its part. Nevertheless, his galloping megalomania, served by a cynicism that Gala's devotion helped to advance, was at the same time to lead to an overwhelming sense of guilt. Hence his daily more frenziedly proclaimed aspiration to link up with the moral and social order which the spontaneous Dalinian demonstrations continually tend to bring into disrepute. An extremely subtle and basically pathetic game is concealed behind the reiterated rodomontades of the *'haute école'* clown that Dali has become. Perhaps the inventor of the 'paranoiac-method of criticism' is trying to forget that he is by no means the very great painter he dreamed of being; in fact he owes his most brilliant contributions to painting to his employment of techniques concentrating on detail but lacking greatness and not at all to impulses of creative genius. This would seem to be Dali's permanent tragedy.

Dax Adrien (Toulouse 1913). The long interrogation concerning the resources of 'automatism' pursued by Adrien Dax with no other consideration beyond his own enjoyment

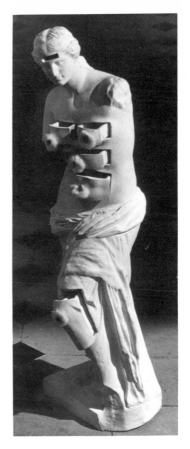

Salvador Dali.
Venus of Milo of the Drawers.
1936. Painted bronze.
Galerie du Dragon, Paris.

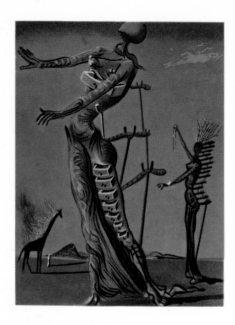

Dali. The Giraffe on fire.
1936. Kunstmuseum, Basel.

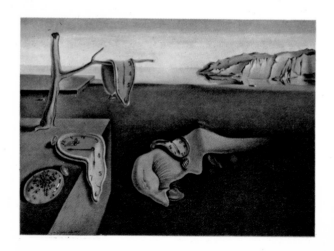

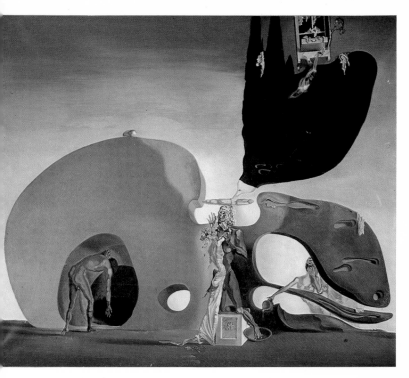

Dali. The Birth of Liquid Desires. 1932. Peggy Guggenheim Foundation.

Dali. The Persistence of Memory. 1931.
◄Museum of Modern Art, New York.

Dominguez.
Decalcomania.
1937. Museum
of Modern Art,
New York.

Dax. The Encounter.
1969. The artist's
collection, Toulouse.

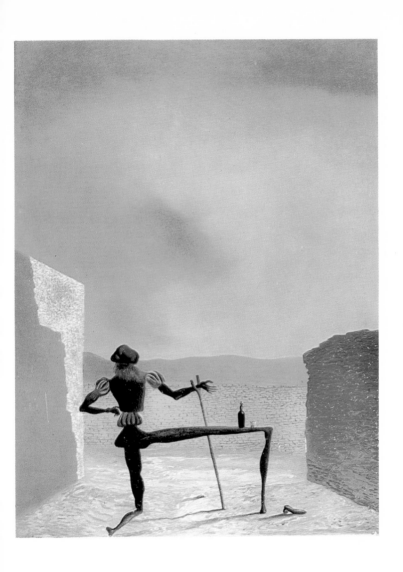

Dali. The Ghost of Vermeer which can be used as a Table.
1934. A. Reynolds Morse collection, Cleveland.

can be traced back to the fascination exercised on him by Max Ernst's admirable *frottages* illustrating *Le Château étoilé* by Breton (No. 8 of *Minotaure*). But it is in the convolutions of arabesques, in which bubbles burst and fructify that, round about the year 1960, he discovers the faithful instrument of his intoxication.

Decalcomania without a preconceived object, also called *'Decalcomania of desire'* (and *'of chance'*). 'With broad brush, spread black gouache, diluted in certain parts, over a sheet of white, hot-pressed paper; cover this with a similar sheet on which you exert light pressure with the back of your hand. Slowly peel off this second sheet by its upper edge as in the normal transfer process, re-applying it and raising it again until the colour is more or less dry. What confronts you at this point may be nothing more or less than Leonardo da Vinci's familiar paranoiac wall, but it is this wall 'perfected'. According to what you discover there, you can now find a title for the image obtained, delaying for a while until you have made sure you have expressed yourself in the most individual and valid manner' (André Breton). This process, described by Dominguez in 1936, was used by Max Ernst in the medium of oil paint.

De Chirico Giorgio (b.1888 at Volo). 'The truly profound work will be drawn up by the artist from his innermost being: down there, no murmur of streams, no song of birds, no rustle of leaves can pene-

trate.' The case of de Chirico along with that of Duchamp presents us with the greatest enigma in contemporary art. The series of incomparable works produced between 1910 and 1919 was followed by a laborious and futile attempt to walk in the steps of the great baroque Venetian painters, obstinately and at the cost of a renunciation of his previous work. A psycho-analytical explanation has been sought for this volte-face; but a mother-fixation and a sense of guilt towards his father (who dies in 1905) hardly provide a satisfactory answer. Others have looked for justification on more aesthetic grounds, claiming that from the time when his painting was accepted and even imitated by Carrà (1916) and even hailed by the surrealists (1920), de Chirico was obliged to change his style. But this hypothesis does not seem very convincing either: how could one accept that an artist should renounce the expression of his genius of his own free will? Everything indicates that de Chirico after several years of a kind of mental derangement (and his writings of the time emphasize the inhibiting nature of his visions and their absence of justification) had woken up 'cured', that is to say he had once more become an artist like any other, without the slightest intervention of his will in so radical a change. De Chirico had painted under the pressure of interior conflicts in the way a medium writes, communicates or acts at the promptings of the 'spirits'. Furthermore, he was at that time persuaded to make continual contact with those ghosts; a fact which con-

De Chirico.
Premonitory Portrait
of Apollinaire. 1914.
Wood engraving
by Pierre Roy.

firms the dissociation of personality that occurs not only with mediums but schizophrenics. If his conscious being (i.e. the painter) functions in accordance with the dictates of the unconscious (the 'spirit'), de Chirico seems the prototype of surrealist artist who aims at reconciling the dual elements ('day' and 'night') of his split personality. He belongs then to a certain kind of automatism although this is manifested not on the level of plastic handwriting but in the transmission of images of an hallucinatory nature. De Chirico paints his dreams, but as if he is painting them in his sleep. Did he not, moreover, write in 1913, 'For a work of art to be truly immortal, it must pass completely beyond the limits of the human: good sense and logic will be absent. In this way it will approach the dream and the mentality of childhood?' In 1929, de Chirico publishes an admirable story in French, *Hebdomeros*, which takes the form of a somnambulatory excursion through the pictorial universe of the period of his genius, the piazzas of Italy (1910-1914) with *'Metaphysical interiors'* (1915-1918).

Deharme Lise. *'O foulard bleu où l'écureuil roux croquait sa noisette et cachait ses trésors, par quelle poule de clocher êtes-vous donc couvé?'* ('O blue foulard, wherein the squirrel cracked its nut and hid its treasures, by what

weather-hen are you hatched out?')
Egeria of the surrealists, she is the
author of the charming, mannered,
exquisite tales of *Cette Année-là*
(1942) and *Pot de Mousse* (1946).

Denmark. Surrealist activity in
Denmark takes its place between the
'cubist-surrealist' exhibition of 1935
and the surrealist exhibition of
1940, with the review *Konkretion*
as the link between these two events.
In the plastic field it is illustrated
chiefly by the painters Vilhelm
Bjerke-Petersen, Harry Carlsson,
Wilhelm Freddie, Rita Kernn-
Larsen, Elsa Thoresen and the
sculptor Henry Heerup. Bjerke-
Petersen (1909-1957), the pivot of
the movement, is more sensitive to
ideas than form in his painting; his
best works have fantastic settings
that sometimes show the influence
of Magritte. Freddie (b.1909) is
closer to Dali, and the aggressive
eroticism of his paintings and his
objects involved him in many
troubles with the police in a Den-
mark not then converted to the
virtues of pornography.

Der Kevorkian Gabriel (Paris
1932). Gabriel Der Kevorkian
would seem to have rediscovered
the secret of Filiger's crystalline
icons (1863-1928), Gauguin's
strange disciple whom Jarry cherished
above all other artists. But here
the monsters, composed of shimmer-
ing facets, are phantasmagoria pro-
testing against the 'monstrosity' of
our repressive society and monsters
only at first sight. In reality they
share that subterranean beauty on
which surrealism bestowed the
freedom of the city.

Desnos Robert (Paris 1900 –
Terezina 1945). 'Have you the
change for my coin? No one in the
world can have the change for my
coin.' It was Desnos who, in 1922,
in the state of 'trances', '*talked
surrealist* at will,' wrote Breton in
the first *Manifesto*, and went so far
as to want to substitute himself for
Marcel Duchamp in the word-
games signed Rrose Sélavy. He
was the first, well before Prévert,
to try to harmonize the surrealist
voice with popular language (*Corps*

De Chirico. The Enigma
of the Hour. 1911.
G. Mattioli collection,
Milan.

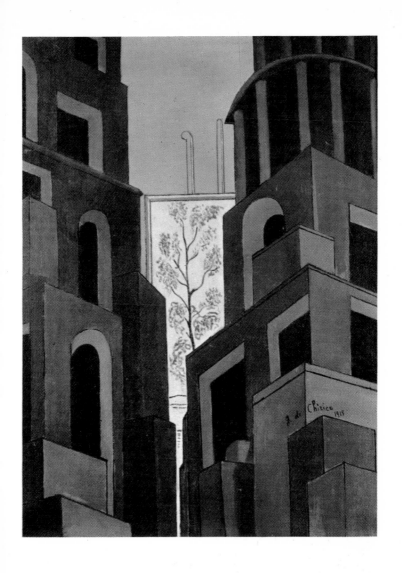

De Chirico. Purity of a Dream. 1915. Private collection, Paris.

et Biens, 1930). As a poet Robert Desnos is dogged by facility from which his recourse to 'nonsense' sometimes saves him (*Langage cuit*, 1923). On the other hand, he is most at home in what we may call the popular surrealist novel with the superb *La Liberté ou l'Amour!* (1927)—his major contribution to the movement. After his break with surrealism (1929), he returned to a traditional form of poetry of little interest. Deported to Buchenwald in 1944, he died in Czechoslovakia shortly after his liberation.

Dialectic. 'Wherever the Hegelian dialectic does not function, there is no thought, no hope of truth for me' (A. Breton, 1952).

Dominguez Oscar (Tenerife 1906 - Paris 1957). Dominguez's contribution to surrealism between 1934 and 1940 is distinguished by his superabundance of new ideas. When he refers to an everyday object—jug, tin of sardines, typewriter or steam roller—and translates it into fantastic terms, it is neither, like Dali, to exploit them for his own glory nor, like Magritte, to use them as witnesses in an action brought against visual logic, but more modestly, to make them participate in man's dialogue with the objects he has created. The cause of automatism is indebted to him, first for the process 'decalcomania of chance' (q.v.) and secondly the vertiginous visions of the 'cosmic' period

W. Freddie (Denmark).
Family portrait.
1938. Collage.

In the foreground: 'Never', object by Dominguez.
The International Exhibition of Surrealism, Paris 1938.

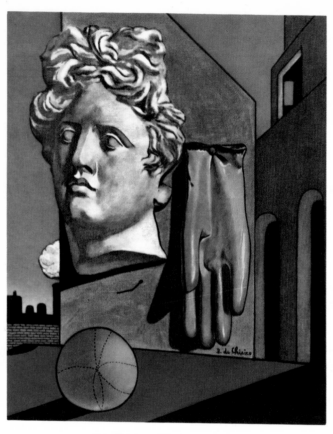

De Chirico. The Love-song. 1914.
Nelson A. Rockefeller collection, New York.

Der Kevorkian. Painting. 1968. Private collection, Paris.

(1939-1940). It is a pity that Dominguez, to whom we owe a number of the most poetic surrealist objects, did not develop his plan for 'lithochronical surfaces'—that is, for integrating the time-element in the making of an artifact. After 1940, Dominguez indulges in pastiches of de Chirico and Picasso, sometimes in one and the same canvas, thus renouncing his own inspiration. It was only about 1954 that he experimented with new, and by no means unpromising, automatic processes. He committed suicide shortly afterwards.

Donati Enrico (Milan 1909). Between 1944 and 1946, in New York, 'automatism' suggests to him the means for creating images of great fluidity, deployed quite naturally to evoke celestial phenomena. Subsequently he moves towards a kind of painting exclusively concerned with 'paint matter', to some extent anticipating Tapies.

Dreams. 'Cannot the dream too be applied to the resolution of the fundamental questions of life?' (A. Breton, 1924).

Duchamp Marcel (Blainville 1887 - Neuilly-sur-Seine 1968). It may soon transpire that the avant-garde of the last dozen years (1960-1972) has gone astray through having staked everything on Duchamp's 'readymades'. These, we should recall, are either manufactured objects, presented as such (bottle-rack, typewriter-cover) or slightly modified (bicycle wheel fixed on a stool, urinal stood on its side, hat-rack nailed to the floor) or, again, objects made by the artist or on his instructions in imitation of manufactured objects (windows of *Fresh Widow* and of *La Bagarre d'Austerlitz*, *Obligation for the roulette of Monte-Carlo*, marble lumps of sugar of *Why not sneeze?*). The key to the meaning of Duchamp's 'readymades' is oddly enough to be found in that artist's note accompanying the title 'Large Glass': 'To separate the *tout fait, en série* (mass-produced readymade) from the *tout trouvé* (all found)—the separation involves an operation.' Since the word *'trouvé'* ('found') here has the sense of invented ('found' by the artist), we are justified in considering that Duchamp's genius was to situate himself in the area which divides the 'readymades' (the *'tout fait, en série'*) from the paintings of 1912 (the *'tout trouvé'*), with each of these extreme positions deriving its significance in relation to the other. This dialectic is confirmed by the fact that the first 'readymade' (*Bicycle wheel*) is dated 1913, the year when preliminary work begins on the painting on glass. *'The Bride stripped bare by her Bachelors, even,'* also commonly known as 'Large Glass' (the execution, begun in 1915, was to be interrupted in 1923). This work of the most outstanding genius in the twentieth-century exploits wholly subjective elements (the 'Bride' who emerges straight from the 1912 canvas of this title) as much as the objective elements (the 'Chocolate Grinder', the model of which was seen in the shop of a Rouen chocolate maker). It operates the 'separation' between the two

extremes of Duchamp's art and uses this 'separation' as the very main-spring of the work which suggests both the similarity and dissimilarity between our erotic universe and that of the machine. Once the 'Large Glass' was '*un*finished', it could have seemed (as it did to the artist himself) that Duchamp had said everything. But from 1946 (when Breton leaves New York for Paris) in the greatest secrecy, Duchamp devotes himself for two decades to elaborating a three dimensional work, a kind of Madame Tussaud's setting which can be seen only through two holes in an old door: a naked woman lying on her back raises an incandescent burner in her hand whilst a waterfall can be distinguished against a landscape background. This work entitled *Etant donnés: 1° la chute d'eau, 2° le gaz d'éclairage* ('Given that: 1° The Waterfall, 2° The Gaslight-ing') and not seen until after Duchamp's death, is a superb indict-ment of the avant-garde whose sole link with him is as dependent on a complete misunderstanding of this second 'apartness' as it is of the first.

Duits Charles (Neuilly-sur-Seine 1925). 'Dawn, transparent swallow, snapped up the fire-flies of the night, one after the other.' Charles Duits is sixteen years old when he meets Breton, who at once recognizes his poetic gifts and persuades him to take part in surrealist activities. Duits has published admirable memoirs of those New York years with Breton: *André Breton a-t-il dit passe* (1969).

Duprey Jean-Pierre (Rouen 1930 - Paris 1959). 'After they had drowned the sea and buried the earth, and the fire had burnt itself out, the air vanished in the smoke of the new fire thereby re-kindled.' Duprey became known through his *Derrière son double* (1950), apropos of which Breton wrote to him: 'You are certainly a great poet, doubled by someone else who intrigues me.' The 'great poet' who moves around in a cataclysmic atmosphere with an inimitable smile, confirms his talent in his posthumous collections *La Fin et la Manière* (1965) and *La Forêt sacrilège* (1970). Do we need to attribute to this 'someone else' who intrigued Breton the paintings Duprey executed in 1951, then the sculpture to which he devoted him-self from 1952? After works brist-ling with wrought iron, he found that cement was the material best suited to his frenzied and equivocal reliefs. Returning to poetry he des-patched his last poems to Breton and hanged himself.

Egypt. The poet Georges Hénein (b. 1914) between 1934 and 1950 is the prime-mover of surrealist activities in Egypt; these take place under the name 'Art and Freedom Group', and thanks to the publisher 'Masses' (Cairo) which issues poems, pamphlets, anthologies, and to the review '*La Part du sable*' (1947). Alongside Hénein, Ramsès Younane and Ikbal-El-Alaily were the out-standing contributors, before Egypt made its most valuable contribution in the person of Joyce Mansour (q.v.).

Dominguez. The Pitchers. 1935.
G. J. Nellens collection. Knokke-le-Zoute, Belgium.

Duchamp. The Bride stripped Bare by her Bachelors, even.
(The Large Glass). 1915-1923. Museum of Art, Philadelphia.

Duprey. Low-relief. 1955. Cement. Private collection, Paris.

Eluard Eugène Grindel, called 'Paul' (Saint-Denis 1895—Charenton 1952). 'And it is always the same avowal, the same youth, the same pure eyes, the same ingenuous gesture of her arms about my neck, the same caress, the same revelation. But it is never the same woman.' Eluard played a major role in surrealism between 1922 and 1938. His lucid and timeless poetry is particularly expressive in *Capitale de la douleur* (1926), *L'Amour, La Poésie* (1929), *La Rose publique* (1934), *Les Yeux fertiles* (1936). But it makes few concessions to automatism; we see rather a frank channelling of the subconscious flow, 'arranged in poems'. Next to Breton, Eluard is of all the surrealist poets the one most interested in painting (*Donner à voir*, 1939). From 1939 he moves towards the French Communist Party and joined it in 1942. He soon became the star poet of this political group.

England. In 1936 The International Exhibition of Surrealism in London exploded like a bomb in the grey atmosphere of English cultural life. The painter, Roland Penrose (b.1900), and the art-critic, Herbert Read (b.1893), were responsible for introducing the surrealist dynamite into this country; Mesens in 1938, Brunius in 1940 tended the flame up to about 1950. Read, David Gascoyne, Hugh Sykes Davies, George Melly and Simon Watson Taylor are the most representative writers of the move-

ment. In the field of sculpture and painting, above all Moore (b.1898), Paul Nash (1889-1946) and Roland Penrose. Moore, who in 1925 'discovered' in the Chacmool rain-god the prototype of his 'reclining figures', is certainly indebted to surrealism (Arp's and Picasso's sculpture, Tanguy's paintings) for the stimulus to break away from the anthropomorphism to which he was to return after 1940. Paul Nash seems haunted by the memories of a legendary past, lost amid the Celtic or even pre-Celtic mists; but

he was too versatile to be fixed in one style. Roland Penrose tried integrating the collage of series of identical postcards into oil-painting, and thereby introduced an intriguing principle of repetition into his work. The other English surrealist painters are Eileen Agar (b.1901), John Banting (b.1902), Humphrey Jennings (1907-1949), Conroy Maddox, Edith Rimmington. It is interesting to note that the contribution by Francis Bacon (b.1909) to the 1936 Exhibition was rejected as being 'not surrealist enough'.

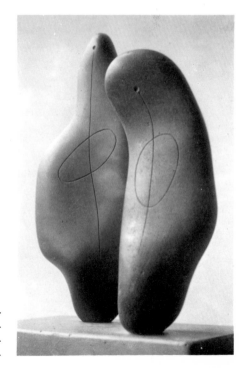

Henry Moore.
Two forms. 1934.
Ironstone.
Private collection.

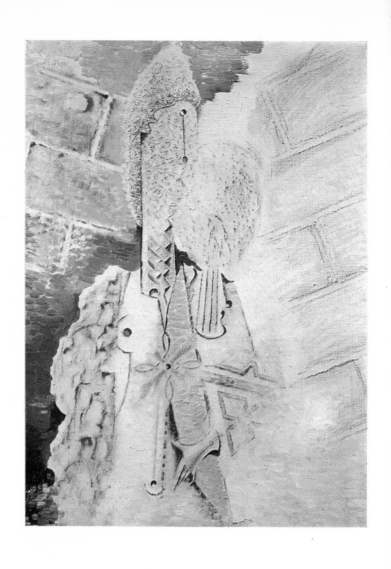

Max Ernst. Two Nude Girls. 1925-1926.
Simone Collinet collection, Paris.

Ernst Max (Brühl, Germany,
1891). 'Is it the man they call
Loplop, the superior of the birds,
because of his gentle but ferocious
character?' Collage of the sur-
realist type which Max Ernst, under
the influence of de Chirico's works,
has been experimenting with since
1919, is his first and perhaps his
most important contribution to sur-
realist painting. It has inspired
countless fantastic pictures of high
quality between 1921 and 1924
(*Œdipus Rex*, *The Revolution the
Night*, *Two Children are menaced by
a Nightingale*). He also invented
the original 'romans-collages': *La
Femmes 100 Têtes* ('The Woman with
100 heads') (1929), *Dream of a
little girl who wanted to enter the
Carmelite order* (1930), *A Week of
goodness* (1934). In 1925 the genre
'frottage', the first results of which
are published in *Natural History*
(1926), open the way to countless
improvements and results which still
continue in Max Ernst's work. A
variant—*grattage* (scraping)—produces
pictures filled with threatening
monsters, gloomy forest, towns
asleep under an ageless moon (1927).
The most impressive works of the
years preceding the Second World
War include the series 'Jardins
gobe-avions' ('Gardens, aeroplane-
catchers') (1935), and that of the
Jungles (1936). From 1937 Max
Ernst adapts the decalcomania
process to oil-painting resulting
between 1939 and 1945 in some of
his best pictures (*Europe after rain*;
the Eye of silence) and then the
'Microbe' series. Interned in 1939
as a German national by the French
authorities, he succeeded in joining
the surrealists in Marseilles whence
he gained New York in 1941.
There he collaborated with Breton
and Duchamp in the founding of
the review *VVV* and met Dorothea
Tanning (1942). In 1944 Max
Ernst began to work again on
sculpture already started in 1934
during holidays spent at Giacometti's
in Maloja. After setting up home
with Dorothea Tanning in Arizona
in 1946, he returned to France in
1953 and settled first at Huismes
in Touraine (1955), then at Seillans
in Provence (1964). The award of
Grand Prix for painting at the
Venice Biennale of 1954 caused
him to be expelled from the sur-
realist movement (the text of the
exclusion was *To his liking*). The
expulsion upset him, and since then
he has never ceased to make harsh
comments on Breton and his friends,
at the same time asserting that he
had left the group in 1938 out of
solidarity with Eluard, a thesis that
does not bear examination and—
equally untenable—that his rôle in
surrealism had always been one of
opposition. Be that as it may, Max
Ernst is now free from the semi-
poverty which had dogged him
hitherto. As for his work, if it
offers no new solutions, it is execut-
ed in the light of his past conquests,
with the occasional success and
always with a consistent refusal to
compromise.

Eroticism. 'If, nowadays, *nature*
(in reference to the outside world)
in art has ceased to be accepted in
its own right, and indeed has been
finally repudiated by some, a priv-
ileged place still survives, namely a

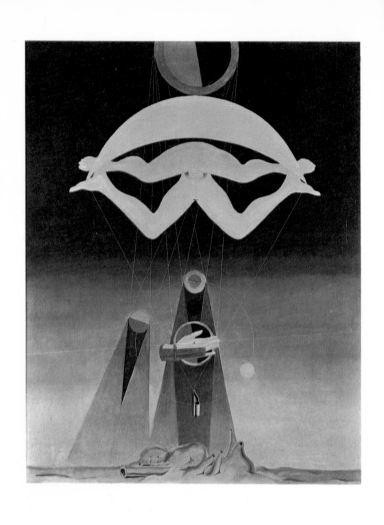

Max Ernst. Men shall know nothing about it. 1923.
Tate Gallery, London.

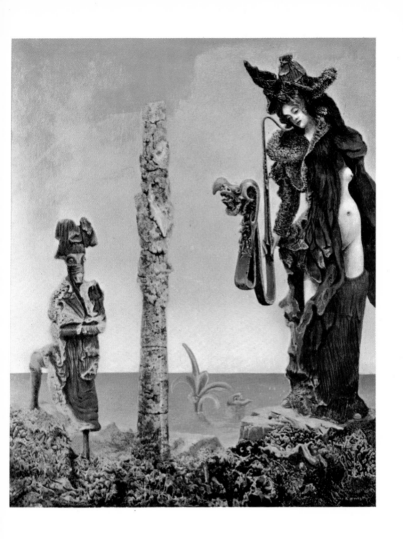

Max Ernst. Napoleon in the Wilderness. 1941.
Museum of Modern Art, New York.

theatre of incitements and prohibitions in which the most fundamental matters of life are played out. This area in which surrealism from its origins to this day has never failed to invade is eroticism (which, as we know, far from demanding the enacting of improper scenes, exploits the ambiguous and lends itself to countless transpositions). The fact is that it is in eroticism— and doubtless in eroticism alone— that the *organic bond*, increasingly lacking in art today, has to be established between showman and spectator by means of perturbation' (A. Breton, 1959).

Exhibitions of surrealism (international). International exhibitions of surrealism have taken place as follows: 1935, at Copenhagen, Santa Cruz in Tenerife and Prague; 1936, in London; 1937, in Tokyo, Osaka, Kyoto and Nagoya; 1938, in Paris and Amsterdam; 1940, in Mexico City; 1942, in New York; 1947, in Paris; 1948, in Prague and Santiago, Chile; 1959-1960, in Paris; 1960, in New York; 1961, in Milan; 1965-1966, in Paris; 1967, in São Paulo; 1968, in Prague. The aim has been not only to exhibit surrealist works of art, but to convey the spirit of the movement in different world centres, while taking each specific local situation into account. Thus, the preparation of these exhibitions tends to become the fruit of collective work for which an appropriate setting is created, realized in accordance with the dictates of the artists and poets involved. In Paris in 1938 the sheets of an unmade

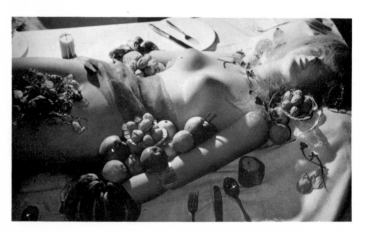

'The Banquet'. International Exhibition of
Surrealism ('Eros'). Galerie Daniel Cordier, Paris 1959-1960.

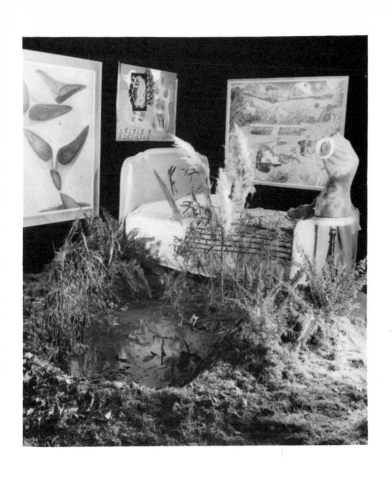

'The Pond'. International Exhibition of Surrealism
(on the wall: paintings by Paalen, Roland Penrose and Masson).
Galerie des Beaux-Arts, Paris, 1938.

Matta. Altar
dedicated to
the 'Gravity-
minder' by
Marcel Duchamp.
International
Exhibition
of Surrealism,
Galerie Maeght,
Paris 1947.

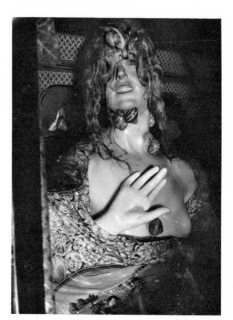

Dali. Rainy taxi.
International Exhibition
of Surrealism,
Galerie des Beaux-Arts,
Paris 1938.

Masson. Girl
with green gag
with a pansy-mouthpiece.
International Exhibition
of Surrealism,
Galerie des Beaux-Arts,
Paris 1938.

bed were reflected on the waters of a small pond; strange shop-window dummies were lined up; the ceiling was covered with 1,200 sacks of coal. In 1942, a gigantic spider's web, installed by Duchamp, enveloped the works on show. In 1947, twelve altars dedicated to mythical beings were set out as an introductory lead-in. In 1959, a panting ceiling and voluptuous sighs invited the visitor to enter a green grotto. In 1965, under the aegis of Fourier's 'L'Ecart absolu' ('absolute apartness'), the case was prepared against 'consumer society' and its wretched myths, from sport to astronautics. In 1968, it was the turn of the 'principle of pleasure' helped by the ephemeral 'Spring in Prague'.

Expulsions. 'I see no serious set-back for surrealism when it has to record the loss of this or that, even brilliant personality, and especially in the event where the latter, in his very act of withdrawing, proves himself to be an incomplete person since he desires to return to normality' (A. Breton, 1929).

Exquisite corpse. 'The most famous of the surrealist games takes its name from the opening sentence that materialized: *'Le cadavre — exquis — boira — le vin — nouveau'* (1925) (The exquisite corpse—will drink—the new wine). It was produced by five players writing in turn subject, adjective, verb, object, complement, each folding over the

71

Fourier Charles (Besançon 1772–Paris 1837). 'In order to arrive at a new continental world, Columbus adopted the rule of *écart absolu* (absolute apartness); he isolated himself from every known trade route and, heedless of the terrors of that century, sailed into a virgin ocean. Let us proceed by a similar isolation; nothing is easier; it is enough to try a mechanism different from our own.' Since 1945, when he wrote the *Ode à Charles Fourier* and during his visit to the Reserves of the Pueblos Indians of Arizona, Breton never ceased to proclaim the genius and the relevance of this prophet of Harmony to our time.

'Exquisite corpse'. 1926-1927. Breton, Morise, Naville, Péret, Prévert and Tanguy. Museum of Modern Art, New York.

paper so that the next player could not see what had been already written. The violent whiff of strangeness and the droll effects obtained by these verbal collages reappeared in the drawn 'exquisite corpses' in which surrealist poets and painters often combined. Despite the fact that each contribution—especially in the case of painters—is relatively identifiable, the total effect (mostly in the form of a 'personage') results from the combined elements. In this, the 'exquisite corpse' can claim to have scored a victory for collective invention over individual invention and over the 'signature'.

'Exquisite corpse'. 1934. Hérold, Breton, Tanguy, Brauner. Hérold collection, Paris.

E. Francès. Return to the earth. 1939. Onslow-Ford collection.

Francès Esteban (b.1914 at Port-Bou). Participates in the revival of automatism manifested in surrealist painting just before the Second World War. Using his original technique of *grattage*, he creates fantastic landscapes, peopled with plant-like creatures. In the United States, during the war, he composes allegorical canvases of powerful rhythms.

Freud Sigmund (Freiburg, Moravia 1836 - London 1939). 'Surrealism has been led to attach a particular importance to the psychology of the dream mechanism in Freud and—in a general way, in the work of this author—to any elucidation of the unconscious based on clinical exploration' (A. Breton, 1935).

Frottage. On 10 August 1925, Ernst, held up by rain in an inn by the sea at Pornic in Brittany, was 'struck' by the obsession exerted upon his excited gaze by the floor with its grain, brought out by countless scrubbings. 'I then decided', he relates, 'to explore the symbolism of this obsession and, to assist my meditative and hallucinatory faculties, I took a series of drawings from the floorboards by placing on them at random sheets of paper which I then rubbed with a soft pencil.' In a similar manner he explored 'leaves and their veins, the frayed edges of a piece of sacking, brush strokes in a modern painting, thread unrolled from its reel, etc.' This process, the first results of which were published in *Histoire*

Naturelle (1926), was soon applied to oil-painting from which Ernst obtains remarkable and very varied effects. It belongs to the various methods of visual stimuli to which Dali applies the term 'paranoiac'.

Fumage. By passing a candle flame over the surface of a sheet of paper, Paalen, in 1937, obtained a fluid and dreamy structure. Transferred to oil-painting, this process allows an 'automatic' rhythm of great flexibility and touches of incomparable fluidity which form the basis of Paalen's pictures at various periods.

Funk art. In 1960, side by side with Pop Art, we see the development, in California around San Francisco, of an extreme form of art, highly coloured, purposely aggressive, humorous or erotic which, without being considered too arbitrary, we can qualify as 'surrealist'. The dictates of the subconscious play a larger rôle than the aesthetic considerations associated with Minimal and Pop Art, and the precarious nature of the works is an important feature. The most remarkable of the Funk artists (an expression borrowed from jazz) are Jeremy Anderson (b.1921) who seems intent on developing Giacometti's surrealist work, Robert Hudson (b. 1926) who introduces pictorial effects into sculpture, William Geis (b.1940) who invents an imaginary bestiary, James Melchert (b.1930), Jerrold Ballaine (b.1934), William T. Wiley (b.1937) and Sue Bitney (b.1942). They are all essentially sculptors.

Games. 'If the shadow of your shadow visited a gallery of mirrors— The sequel would be indefinitely postponed to the next number.' From the 'Exquisite Corpse' (1925) to 'L'Un dans l'autre' (q.v.) (1954) and the game of 'questions and answers' (1928) to the 'card of analogy' (1957), games held a front-rank place in the surrealists' daily life. Apart from the pleasure of playing and the eagerness to verify the cohesion of the group through games, they doubtless contributed to the acquisition and exploration of the fundamental options of the movement in an uninhibited manner: attitude towards the great names of history, art or literature ('notations', 'do you open?', 'card of analogy'), signification of the poetic image ('exquisite corpse', 'questions and answers', 'L'Un dans l'autre'), morals ('the truth game'), and more generally, poetic attitude extended to every aspect of life (proposals for the 'irrational embellishment of a town', interpretations of a picture by de Chirico, of a film by Josef von Sternberg, etc.). 'It seems that the surrealist game,' writes Philippe Audoin, 'would propose to restore man to his condition as son of the sun, in other words as possessor of the 'philosopher's stones'.

Gerber Theo (near Thoune, Switzerland, 1928). In 1965 Gerber's landscapes swept by wind and water are followed by a space-structure composed of hallucinatory, sometimes erotic, elements. Onirism intervenes increasingly as the organizing principle of the picture, orchestrating strips of sky and

Gerber. Imaginary Spring. 1970. Philippe Woog collection, Geneva.

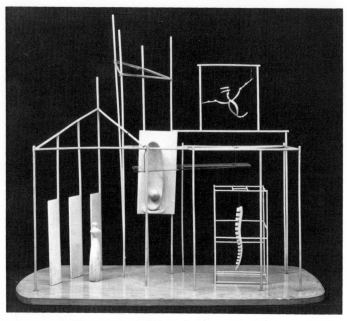

Giacometti. 'The Palace at 4 P.M.' 1932.
Wood, glass, metal and string. Museum of Modern Art, New York.

Giacometti.
The Invisible Object.
1934-1935.
Bronze. ▶

Giacometti.
The Suspended Ball
of the Hour of Traces.
1930. Plaster maquette.

pillars of cloud with female hips and oases of pure fantasy. Towards the end of 1968, Gerber's painting attains a lyrical style in which freedom is combined with an ever-renewed assurance of composition, which invites comparison with the most inspired works by Kandinsky, Picabia or Matta.

Giacometti Alberto (Stampa 1901 - Coire 1966). It was a kind of mental disturbance that led Giacometti to surrealism. This pupil of Bourdelle's had the sensation that the object was moving away from him whenever he tried to represent it, and every form of realism became impossible. After finding his inspiration for a time in Primitive art, notably African, which helped him to break away from literal representation, he had to liberate himself from an aesthetic schematism which was liable to strip his work of all emotion. Surrealism helped him to find the direct inspiration for the work of art in himself and no longer in exterior models provided by nature or civilization. *The Suspended Ball* or *The Hour of Traces* (1930) which was to stimulate the genre, the 'surrealist object'. was the first of his new sculptures; it translated a disturbing sensation since it suggested a caress which could not be wholly completed. *Cage, Point in the Eye, Disagreeable object to throw* (1931), *Woman with her throat cut* (1932), *Flower in Danger* (1933) had their genesis in the spontaneous projection of waves of aggression or self-destruction. The first masterpiece of this period was to be *The Palace at 4 P.M.* (1932), a veritable

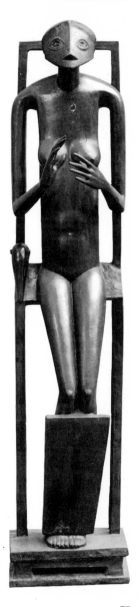

PROBLEME N°14

Giovanna. Cross-enamels. 1972. Private collection.

Gironella. Grand Queen. 1964. Private collection.

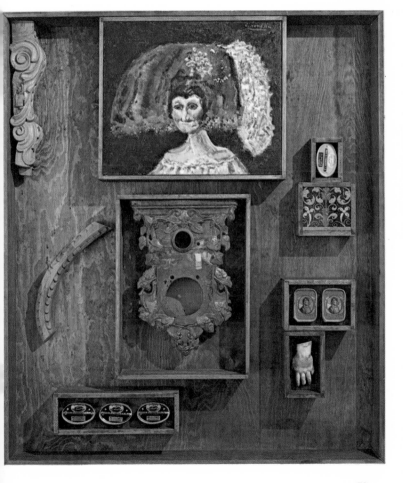

mise-en-scène of an amorous adventure of the artist which recalled the subjective significance of space in the early de Chirico. In fact, Giacometti calmly executed his works 'to the dictation' of inspiration, then re-discovered the fertile passivity of the painter of the piazzas of Italy and *Metaphysical Interiors*. Giacometti's other great surrealist work *The Invisible Object* (1934-1935) was to close this period with what is possibly the most mysterious sculpture of the twentieth century. Breton, who has described the hazards of its completion, considered it to be 'the very emanation of the *desire to love and to be loved'*. In 1935 Giacometti moved away from the surrealists and tried in vain for ten years to return to the human figure: faces or silhouettes were thinned down between his fingers until there was virtually nothing left. But in 1947 he finally contrived to capture these filiform and haggard figures, now motionless, now in an incredible hurry, which made his reputation and through which he now described from the exterior that ineradicable anxiety which for some time he had represented from the interior.

Giovanna (b. Reggio-Emilia). With Jean-Michel Goutier, c.1965, she works out an original idea for a poetic spectacle. At the same time she devotes her attention to graphic experiments, making an individual use of typewriter characters. Then, in 1971, she builds up a series of coloured drawings on a basis of blown-up photographs of crossword patterns.

Gironella Alberto (Mexico City 1929). In 1958 he undertakes an exploration of some specific works of the past (for example Goya's *Queen Maria-Luisa of Bourbon-Parma* or Velasquez' *Queen Maria-Anna*) with which he establishes the strangest of dialogues, a mixture of adoration and 'devoration', celebration and destruction, as if he was simultaneously conjuring the work from time and death and was identifying himself with it. In plastic terms this leads him to develop a 'paranoiac' type of commentary on chosen works for which he brings into play not only drawing and painting but various 'assemblage' processes in two or three dimensions.

God. 'Everything that is collapsing, shifty, infamous, sullying and grotesque is summed up for me in this single word: "God"' (A. Breton, 1925).

Gorky Vosdanig Adoian, called Arshile (Hayotz Dzor, Turkish Armenia, 1904 - Sherman 1948). A long and patient assimilation of modern painting led Gorky, who emigrated to the U.S.A. at the age of sixteen, towards Cézanne, then Picasso, finally, from 1940, Miró. Kandinsky and Masson reinforced his desire to achieve painting that lends itself to an immediate yet profound effusiveness. But the decisive experience of his life was his encounter with Breton and Matta in 1944. The warm friendship which Breton immediately showed him, despite the fact that Breton hardly spoke a word of English and Gorky no French, encouraged the

painter to have confidence in his own genius. For his part, Matta helped him to resolve a number of technical difficulties concerned with the practice of automatism. As Gorky's dealer, Julien Levy, himself the author of a surrealist anthology (1936) writes: 'For Gorky, automatism spelt redemption.' And in point of fact, Gorky adapted automatism miraculously to his personal sensibility. In his work alone, among that of the surrealists, the love of nature finds expression in a careful study of plants and flowers. And it is through the combination of these extremely sensitive studies and lines, forms or colours, spontaneous and subjective creations, that this American painter achieved those superb compositions which occur between *The Liver is the cock's comb* (1944) and *The Plough and the Song* (1947). Memories of an Armenian childhood also combine with subconscious imagery and notations from nature. Doubtless it is to these that we owe the fantastically glowing colours which make these canvases so brilliant and moving. Gorky proceeds by squaring up one of his vibrant drawings on the canvas. More often than not, the same theme or even the same drawing, transferred to several canvases, serves as a starting-point for various versions, each one closely linked with the moment of its execution. But Gorky was a target for misfortunes: early in 1946 twenty-seven of his paintings were destroyed by a fire in his studio, then followed a serious operation for cancer, an emotional tragedy and a motor accident in which he dislocated his neck and broke his right hand. When he hanged himself, American painting lost its first hero and surrealism one of its greatest poets.

Gracq Louis Poirier, *called* Julien (Saint-Florent-le-Vieil, 1910). 'In evening dress, leaning on the mantelpiece and toying with my revolver in a theatrical manner, I gazed idly at the green still water of those ancient mirrors...' Although he has published prose poems (*Liberté grande*, 1947) and a play inspired by the legend of the Holy Grail (*Le Roi pêcheur — The Fisher King*, 1948), it is in the novel that Julien Gracq offers a new ouverture for surrealism in *Au château d'Argol* (1938) which, in its veiled hysteria, links up with the spirit of the 'romans noirs' (q.v.).

Granell E.F. (Corunna, Spain, 1912). At Santo Domingo, in Guatemala and in Puerto Rico, Granell played an important rôle in the spread of surrealism during the Second World War before he settled in New York. His painting of great charm is sometimes dominated by rhythm, sometimes by the fantastic.

Grattage. It begins as an extension of *frottage* (q.v.), with Max Ernst substituting oil-painting for lead pencil and canvas for paper (1927). It then develops into the process invented by Francès around 1938: superimposed layers of colours are attacked with a razor blade producing unexpected transparent and diapered forms.

Gorky. The Betrothal II. 1947. Whitney Museum
of American Art, New York.

Gorky. Agony. 1947. Museum of Modern Art, New York.

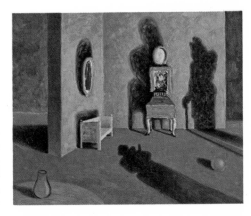

Stellan Mörner.
Play of shadows.
1938.
Mary Ann Forssell
collection,
Djursholm.

Halmstad group. A group of Swedish painters settled at Halmstad on the Kattegat come under the influence of surrealism from 1930 to 1939. Sven Jonson (b.1902), Waldemar Lorentzon (b.1899), Stellan Mörner (b.1896), Axel Olson (b.1899), Erik Olson (b.1901), Esaias Thorén (b.1901) all participate in the fantastic current started by Magritte, Dali and, to a lesser degree, Tanguy. The most remarkable are Erik Olson and Mörner; the former in his transfigured landscapes, the latter in still-lifes or visibly haunted interiors.

S. W. Hayter. Palmistry. 1935.
Engraving.

Hantaï Simon (Bia, Hungary, 1922). Towards the end of 1952 he made the acquaintance of Breton and the surrealists, who gave him a warm welcome. Hantaï at that time had produced work in which the automatic element is combined with a fantastic vision, particularly tragic and agonized, in which the presence of the human being is implied by the insertion of animal skulls on the canvas. Later his pictures are invaded as far as the eye can see with heaving piles of monstrous and garish entrails. Hantaï's particular megalomania leads him to play a decisive role in the expulsion of Max Ernst from the surrealist group. Following which, in 1955, he himself breaks away from surrealism and falls under the spell of Georges Mathieu's reactionary charisma. He is converted to Roman Catholicism and in 1957 organizes demonstrations commemorating the condemnation by the Inquisition in the thirteenth century of the Averroist, Siger de Brabant, demonstrations of an 'integrist' and fascistising spirit which the surrealists denounce in their pamphlet, *Warning Shot*.

Hare David (New York 1917). In touch with the surrealists and following research on the American Indians, Hare turns sculptors in 1944 and, with an imagination rich in humour, invents droll or aggressive figures, the suggests natural scenes in a lyrical vein.

Hayter Stanley William (London 1901). Founder of the famous 'Atelier 17' in Paris, 1927, Hayter participated in surrealist activities

Hérold.
La Femmoiselle.
1945. Bronze.

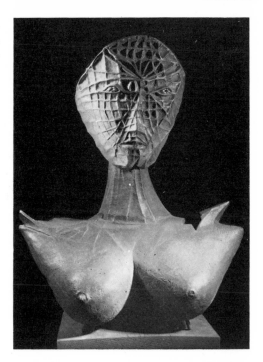

between 1934 and 1940. Recourse to automatism has helped him to liberate himself from the human figure in both engraving and in painting, and we can detect the influence of his lively and authoritative line in the work of the early Matta.

Hegel Georg Wilhelm Friedrich (Stuttgart 1770 — Berlin 1831). 'Hegel tackled all the problems which arise in the field of poetry and art at the present time, and he has solved a large proportion of them with unparalleled lucidity... Even today it is to Hegel we turn to question the soundness or otherwise of surrealist activity' (A. Breton, 1935).

Heisler Jindrich (Chrast, Czechoslovakia, 1914 — Paris 1953). He contributes the valuable resources of a particularly acute poetic mind, orientated towards the relationships of words and visual images, first to the Czechoslovakian surrealist group in 1938, then to the Paris surrealists from 1947, up to his death. His *'poèmes réalisés'*, his 'alphabet', his 'book-objects', his original design in the review *Néon*, are but a few of his many contributions.

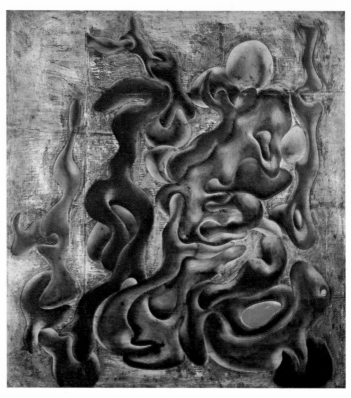

Hantaï. Untitled. 1953-1954. Private collection, Paris.

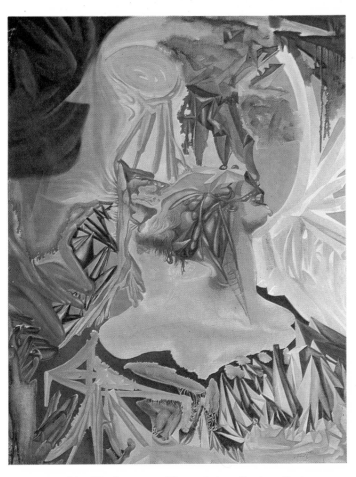

Hérold. Heads. 1939. The artist's collection, Paris.

Henry Maurice (Cambrai 1907). Initially attached to the group the *'Grand Jeu'*, he took part in surrealist activities between 1930 and 1951. Known mainly for his irrational humorous drawings, he is also the author of paintings, objects and reliefs which show the same placid and uneasy humour, the assured statements of the inadmissible.

Hérold Jacques (Piatra, Rumania, 1910). *'Dans mes orbites, les cristaux se reposent'* ('In my orbits, the crystals repose'). Three key events inform Hérold's work: a motorcyclist getting up apparently uninjured from a crash, letting his blood spurt in thin streams; a small pastry cook spattered with *croissants* on a wall against which a derailed tram had flattened him; the face of a girl accident casualty from whom the skin is curling off like so many shavings. These obsessive images, even when they seem to fade out in a nebulous atmosphere starred with lights, have never ceased to inspire Hérold's drawings, paintings and his few sculptures. He drew close to the surrealists in 1932 but drifted away from them in 1951.

Holten Ragnar von (Gleiwitz 1934). A great Gustave Moreau specialist and author of a study on *'Surrealism in Swedish Art'* (1969), he organized the exhibition 'Sur-

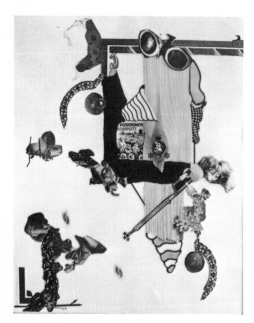

R. von Holten.
Purée complète. 1971.
Collage.
The artist's collection,
Stockholm.

Valentine Hugo.
Cover for the
'Strange Tales'
by Achim von Arnim.
1932-1933.
Drawing.

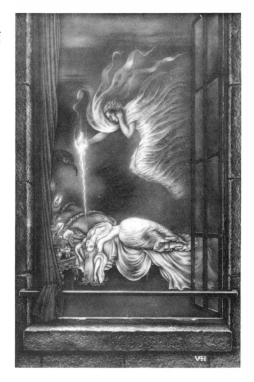

realism' in Sweden in 1970. Further, he works as a painter and is particularly noted for aggressive, sensitive and droll drawings and collages such as the illustrations for *Les Chants de Maldoror* (1966-1972).

Hugnet Georges (Paris 1906). From 1932 to 1939 he participated in surrealist activities. He is the author of a fine poetic film *La Perle* (1926). His best volume of collected poems is *Le Chèvre-Feuille* (1943). He also published *L'Aventure Dada* (1957). In 1962 he was assaulted by V. Bounoure in the presence of J. Mayoux and J. Schuster for having uttered libellous statements about Péret in the journal *Arts*.

Hugo Valentine (Boulogne-sur-Mer 1887—Paris 1968). She took part in surrealist activities between 1930 and 1939, decorating and illustrating their books, their reviews, their exhibitions with jewel-like drawings and paintings. She was also the creator of one of the first 'surrealist objects' (q.v.) (1931).

Humour noir. 'Black humour is a derisive laugh which originates in the rebellious part of the ego and provokes and defies public opinion and the cosmic lot' (M. Carrouges). *L'Anthologie de l'humour noir* by Breton, due for publication in 1940, was censored by the Vichy government and did not appear until 1950. It starts with Swift, Sade and Lichtenberg, celebrates among better known names, Lacenaire, Grabbe, Forneret, Cros, and picks out for special honour Allais, Brisset, Synge, Jarry, Roussel, Cravan, Vaché and, from Duchamp onwards, deals with numerous surrealists, including Arp, Péret, Prévert, Dali, Carrington.

Immaculée Conception (L'). 'It is I who have had to amputate the woman from the man's sex under the pretext of aesthetic surgery.' In this poetic work, written in collaboration by Breton and Eluard in 1930, the newest part consists of five 'essays of simulation' of the troubles of language in various mental maladies (mental debility, acute mania, general paralysis, delirium of interpretation, *dementia praecox*). For the authors, it is a question, first and foremost, of abolishing the limits which reason—under the pretext of preserving social order—claims to set between men and forms of expression. Fifteen years before the *Art brut* offensive, it also advances proof of the creative powers of madness.

Interior model. 'On the faith that man is capable only of reproducing with a greater or lesser degree of success the image of whatever moves him, painters have shown themselves far too compromising in their choice of subjects. The error committed was to suppose that the subject could be taken only from the exterior world, or even that it could be taken there only... The plastic work, if it is to correspond to the necessity for absolute revision—on which all minds agree today—of real values, must have reference to a *purely interior subject* of it will not be' (A. Breton, 1925).

Japan. Since 1930 surrealism has owed its penetration into Japan to the tireless efforts of the poet Shuzo Takiguchi (b.1903). This was initially manifested in the field of painting, thanks first to Harue Koga (1895-1933) and to Ichiro Fukuzawa (b.1893), then to younger artists such as Aïko, Taro Okamoto (b.1911), Shigeru Imai, Noboru Kitazato, R. Otsuka, Y. Shimozato and Ayako Suzuki. More individual contributions to a fantastic art, close to surrealism, come from Jiro Oyamada (b.1915) and Masao Tsuruoka. In 1941 Takiguchi and Fukuzawa were imprisoned by the secret police since the military régime banned anything that smacked of avant-garde freedom of thought. After his liberation, Takiguchi took part in the study circle clandestinely organized by the Marxist theorist Jun Tozaka. After the end of the Second World War, Okamoto, advocating a kind of dialectical synthesis between the twin poles represented by abstract art and surrealism, exercised a considerable influence on the avant-

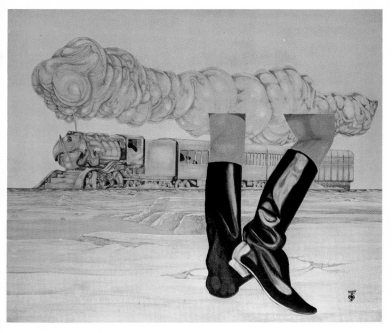

Hiroshi Nakamura. Boots and Train, 1966. The artist's collection.

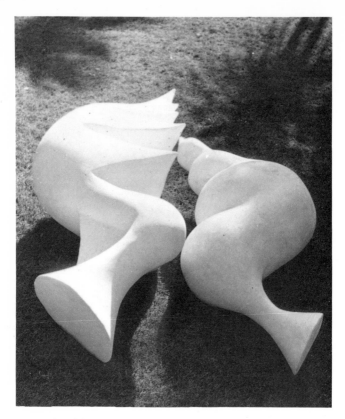

Taro Okamoto. Love. 1961. Plaster.

garde revival in Japan. Later surrealism and Dadaism coalesce in the group of artists formed by Gempei Akasegawa, Shusaku Arakawa (b. 1936), On Kawara (b.1933), Tetsumi Kudo (b.1935). Poets, the most remarkable of whom is Koïchi Ijima (*Other People's Sky*, 1952), and art critics compose a new surrealist study circle. Jun Ebara concentrates on the relations between surrealism and communism. From 1960, Takiguchi brings the spirit of automatic calligraphy to bear on his painting. Tatsuo Ikeda is a remarkable draughtsman who reminds one of Brauner. Isao Mizutani displays a grimacing but inspiring fantasy. Hiroshi Nakamura (b.1932) achieves a brilliant reconciliation of a certain Pop spirit with a truly visionary intensity. Surrealism likewise reaches

the cinema with Kobo Abe (*The Woman of the Dunes*), ballet with Tatsumi Hijikata, the experimental theatre with Juro Kara. Finally, the greatest cultural scandal in Japan since 1945 was the case of Akasegawa, accused of having exhibited the reproduction of a Japanese banknote (1967), an act in which, writes Takiguchi, *expression* is categorically united with a real *action*: "humour noir" is thus simultaneously set up against the monetary system and the established conception of art.'

Jarry Alfred (Laval 1873 — Paris 1907). 'Horngibolets! we shan't have demolished everything if we don't demolish the ruins as well!' The man responsible for *Ubu Roi* is also author of disturbing symbolic poems *Minutes de sable mémorial*, the prophetic confrontation of man versus machine in *Le Surmâle*, the mystic and erotic speculations of *L'Amour absolu*, of the symbolic odyssey of Doctor Faustroll and other strange and profound works. So that Lautréamont is his sole contender for the first place among the surrealist immortals.

Jean Marcel (La Charité-sur-Loire 1900). From 1933 to 1951, he took part in surrealist activities, producing engravings and shrill, curlicued drawings (*Mourir pour la patrie*, 1935), then critical studies in collaboration with A. Mezei (*Maldoror*, 1947; *History of Surrealist Painting*, 1959).

Jouffroy Alain (Paris 1928). 'The majority of men spend their time hiding from themselves the fact that they are revolutionaries.' After participating in the surrealist movement from 1946 to 1948, he becomes a reputed art critic (*Une Révolution du regard*, 1964). A sensitive poet, he is occasionally carried away by eloquence (*Aube à l'antipode*, 1966). Since Breton's death he has worked for the posthumous reconciliation of the latter with the apparently still living Aragon.

Kiesler Frederick (Vienna 1896 — New York 1966). Inventor of 'the House without end' (1924-1933), inspired by organic forms to produce 'inner peace', he makes contact with the surrealists on the occasion of the erection—from his plans—of the Gallery Art of the Century at New York (1942). Defender of 'a magic architecture' as opposed to 'functional architecture' (*Manifesto of correalism*, 1949), in 1947 he presided at the inauguration of the International Exhibition of Surrealism at the Galerie Maeght, Paris. He can be considered the first contemporary surrealist architect.

Klapheck Konrad (Düsseldorf 1935). At the age of twenty as a protest against the increasing vogue of *art informe*, he decides to paint a typewriter in the most photographic way possible, thus anticipating Pop Art by five years and Hyperrealism by ten. But he immediately discovers that this challenge authorizes, in fact, the most exact expression of his subjectivity and that the machines that preside over our daily life mime to perfection man's desires and taboos. Thus the typewriter is a father-substitute, the

sewing-machine a mother figure, the taps and shower-bath roses represent sex appeal, bicycle bells childhood memories, the telephone the superego; all this not by virtue of an arbitrary decision, but of a symbolism which occurs spontaneously to the artist. For under the frozen splendour of Klapheck's canvases seethe irrepressible passions. His first contacts with the surrealists go back to 1960 and he has every justification for considering himself one of their number, closer however to Tanguy than to Magritte, if only in his compulsive desire to select forms of inexorable beauty.

Lagarde Robert (Béziers 1928). A virtuoso draughtsman, he evolves complex torsos or knotty tree-roots in a mental space which he makes his own. Automatism here does not open on to lyricism, nor on to a cosmic viewpoint, but rather on to interior gardens whose minute and continuous efflorescence are reminiscent of coral—reefs.

Laloy Yves (Rennes 1920). His work, which gets off the ground alter his brilliant *Great Helmet* -1959), takes three directions: one, where symbolism, based on analogy, is reinforced by phonetic

Robert Lagarde.
Pen and ink
drawing. 1960.
Private collection,
Paris.

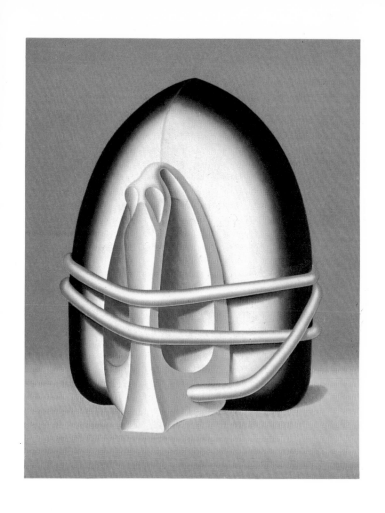

Klapheck. The Hostage. 1966. José Pierre collection, Paris.

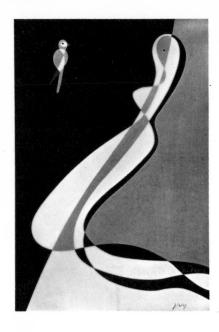

Yves Laloy.
Woman and Bird.
1971. Private
collection, Paris.

punning (*les Petits pois sont verts ...
les Petits poissons rouges*)*; the other
in which curves dominate and the
dynamism is revealed in submarine
fauna and flora as a kind of lyrical
springboard; finally a third, go-
verned by straight lines, interrupted
by straight lines, interrupted by
circles, in which the sam of trian-
gular forests strikes a triumphant note.

Lam Wifredo (Sagua la Grande,
Cuba, 1902). 'In times like ours,
we shall not be surprised to see

displayed here, with horns, the *loa
Carrefour* (*Eleggià à Cuba*)—which
blows on the wings of the doors'
(A. Breton). With 'the loa Car-
refour,' the goddess of love *Erzulie*
or the god of war *Ogoun Ferraille*,
the whole mythology of Haitian
Voodoo from the year 1942 in-
vades Lam's paintings. Himself a
descender of very ancient civili-
zations (Cuban-negro mother, Chi-
nese father), Lam finds himself able
to echo their ancestral excitement
through Voodoo, so close at hand,
and thanks to the encouragement to
listen to everything that slumbered
in him which Breton and the sur-
realists showed him from the time
when, at Marseilles in 1940, he

* *Untranslatable — play on 'pois' — 'poisson'
and 'vert' and 'rouge'. Poisson rouge =
goldfish. cp. Lewis Carroll's 'Bread-and-
Butterfly', etc.*

shared their interests and their games. Thus, it is under the sign of a famous painting *The Jungle* (1943, Museum of Modern Art, New York), which shows a spectacular fusion of tropical vegetation with human beings, that Lam's self-conquest is fulfilled. From this moment onwards the bewildered cavalcade of desires sweeps through his canvases, mingling its violence with the winged speed of its lusts: in fact his paintings, above all following a stay in Haiti, show us nothing but neighing steeds, shivering plumes, wild charges, barbed arrows, bird-cries, horns and claws ready to eviscerate... Rarely has the universe of instincts manifested itself so spontaneously in its pulsating truth and primordial freshness; and in such a way that we are obliged to agree that what rational man thinks of as linked with darkness and horror is here revealed as the fundamental source of beauty and the vital balance of nature. But the purposely subdued colours indicate that our imaginations are meant to surrender to the approach of darkness, twilight, or dawn when mountain tops are white and flowers

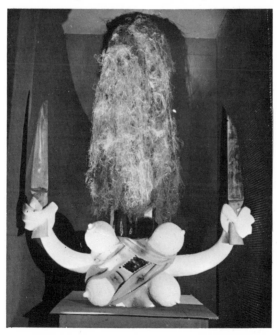

Lam. Altar for 'La chevelure de Falmer' from *Les Chants de Maldoror*. 1947.

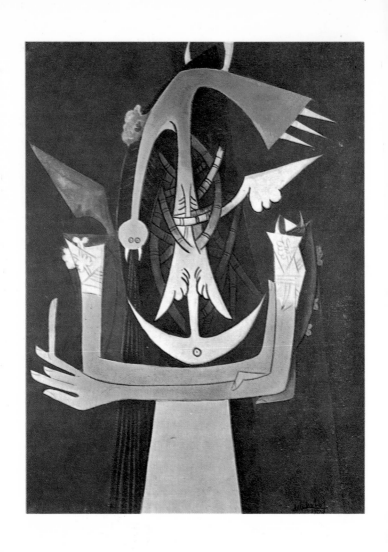

Lam. Luguando Yembe. 1950. Private collection, Paris.

Lam.
We are
waiting.
1963.
Private
collection.

Lam. Tropic
of Capricorn. 1961.
Sonja Henie
collection.

open. At such a time the flights of desire are drawn with a line like the trajectory of a stone, eyes shine, waists tauten, claws open, lubricity ripens: in the veiled light through which the bright ridges of colour make their voice heard, Lam's universe prepares for love-making.

Lautréamont Isidore Ducasse, *called* Comte de (Montevideo 1846 — Paris 1870). 'I consider that the greatest claim to glory of the surrealist group is to have recognized and proclaimed the ultra-literary importance of the admirable Lautréamont' (A. Gide). Aragon, Breton and Soupault discovered *Les Chants de Maldoror*, in 1918, then *Poésies*. No other poet is to enjoy in the surrealists' eyes the aura with which Lautréamont is invested. He is the decisive example which forced them to identify the mechanics behind *Les Chants de Maldoror* and, at the same time, to apply the dialectic which is established between this work and its apparent negation in *Poésies*.

Lebel. Jean-Jacques (Paris 1936). He takes part in surrealist activities between 1956 and 1959. Then he introduced the 'happening' into France and later worked zestfully and indefatigably to sweep aside the barriers between the little splinter-groups along with their shibboleths.

Lebel Robert (Paris 1904). 'From a café terrace where I often sit at the intersection of two broad boulevards, I enjoy a viewpoint from which and where I not only look down on miracles but also watch them approaching from the distance. Associated with the surrealist movement since his New York years, Robert Lebel passes a calm but cynical glance over human beings and inanimate objects which informs both the sibylline stories of the *Oiseau caramel* (1970) and his writings on art, which include the exceptional *Sur Marcel Duchamp* (1959), the most penetrating study so far devoted to this artist.

Legrand Gérard (Paris 1927). 'My eyes will close—Before human vermin—Have settled on the stars.' Associated with surrealism from 1948, Legrand is the poet of the euphoria of the moment (*Des pierres de mouvance*, 1953; *Marche du lierre*, 1969) and at the same time the philosopher who, better than anyone else, has revealed what unites the pre-Socratic Greeks with surrealism (*Préface au système de l'éternité*, 1971).

Leiris Michel (Paris 1901). 'To return to the primal source.' Leiris was nearly lynched in 1925 at the banquet Saint-Pol-Roux for having shouted: 'Down with France! Long live Germany!'* However, every work by Leiris seems to come from somewhere far removed from everyday life, but where the most ele-

* *It is only fair to add that at this banquet at the Closerie des Lilas, a Paris café, Rachilde had said in a stage-whisper 'une Française ne peut pas épouser un Allemand'. Leiris made these remarks at the climax of the riot that ensued. The period was marked by the vindictive attitude of Poincaré towards the conquered Germans.*

mentary physical sensations assume an unexpected vivacity, a new resonance, whether in poems (*Haut Mal*, 1943), tales of dreams (*Aurora*, 1946), reminiscences (*L'Age d'homme*, 1938; *La Règle du jeu*, 3 vols 1948-1966). A moving effort to reach profound truth and, thereby, illume the road of revolt, gives Leiris' works a particular importance.

Le Maréchal (Paris 1928). In his engravings and paintings, he describes a kind of madreporic proliferation which invades town and countryside and gnaws into them. This aroused the interest of the surrealists, already in 1957.

Limbour Georges (Courbevoie 1900 - Spain 1970). 'My limbs will grow again in the brightness of the night.' Poet in the Apollinaire and Max Jacob tradition (*Soleils bas*, 1924), he showed his paces in some delicate and slight stories (*L'Illustre cheval blanc*, 1930; *L'Enfant polaire*, 1945), then in the novel *La Chasse au mérou* (1963).

Luca Gherasim (Bucharest 1913). 'The void voided of its void is fullness.' Along with Trost, he revitalized the Rumanian surrealist group in 1941 before he settled in Paris in 1948. He explored the sonorities of language *ad absurdam* (*Héros-limite*, 1953-1970) just as in the three-dimensional field he systematically studied the intervention of chance in the elaboration of the image ('*cubomania*,' 1945). He has also advocated 'the unlimited erotization of the proletariat'.

Mabille Pierre (1904-1952). Doctor and psychologist, inventor of the 'village test', his special contribution to surrealism was his lively curiosity, fed by a store of esoteric knowledge. His *Miroir du merveilleux* (1940) is an exciting incursion into the limitless field of carnal desire.

Magloire-Saint-Aude Clément (Port-au-Prince, Haiti, 1912). *'Je descends, indécis, sans indices—Feutré, ouaté, loué, au ras des pôles...'* ('I descend, irresolute, unheralded—on noiseless tread, padded, praised, on a level with the poles...') . The essential Magloire-Saint-Aude is contained in three slim volumes: *Dialogues de mes lampes*, *Tabou* (1941), *Déchu* (1956). His poetic output is slender but intriguing.

Magnetic fields (The). Convinced by a half-dreamed phrase (which psycho-analysis seemed to confirm) that a speech or piece of writing can be abstracted from the control of reason, Breton wrote in 1919, jointly with Soupault, and within a week, the first surrealist book, whose title evokes at once *Les Chants de Maldoror* and the property that words in automatic writing possess of exercising magnetic attraction on each other. The two authors prove the various potential 'attractions' of automatism and the possibility of combining automatism fruitfully with other preoccupations (childhood memories, for example, in the case of Breton's *Saisons*).

Magritte René (Lessines 1898 - Brussels 1967). The discovery of a

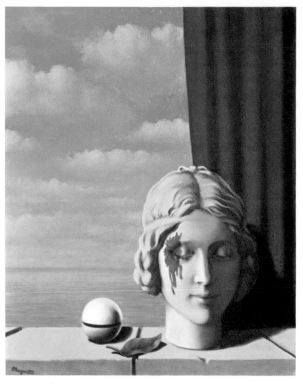

Magritte. Memory. 1948. Collection of
the Administration of the Fine Arts, Brussels.

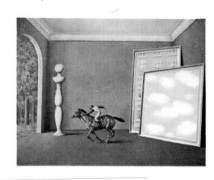

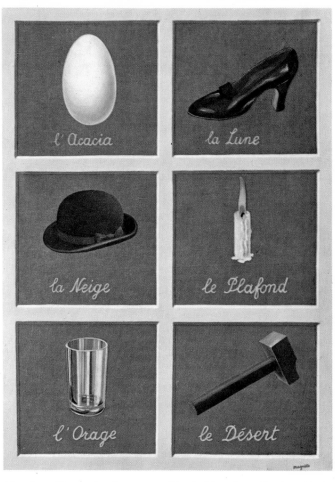

Magritte. Dream-books. 1930. Claude Hersaint collection, Paris.

◄ Magritte. The Childhood of Icarus. 1960.
Alan H. Kempner, New York.

reproduction of de Chirico's *Love-song* in 1922 proved decisive for Magritte. In fact three years later his first original paintings appear almost as if they were a sequence to the Italian painter's *'Metaphysical interior'*. A somewhat theatrical space provides the setting for strange and delusive encounters. But almost immediately Magritte embarks on a systematic exploration of the resources of pictorial representation with the addition of intriguing captions. Magritte's pictures attempt to answer such questions as: Why should a statue not bleed? Why should a window-pane not form part of the landscape one perceives through it? Why should not any form signify this or that precise object? What difference is there between an object and its *trompe-l'œil* appearance? And, in a more general way: why should painting not persuade us that certain things are possible which we previously considered impossible? Such an enterprise, which proceeds from an extremely coherent logic, early induced Magritte to adopt a descriptive technique of sober fidelity, well adapted to endowing the figurative elements with the necessary impersonality. It was important that the objects depicted should be recognized without difficulty so that the absurdity or obviousness of their dialogue should make an immediate impact. His painting depends first and foremost therefore on an effective technique, and one can qualify his pictures as successful only if they produce the desired aim. This does not absolve a number of his canvases and drawings from a certain mediocrity. However, there are some admirably executed paintings, as if the lyricism of the title had wrenched the painter away from his normal choice of grey tones and the aggressive clumsiness which he normally imposes on himself. But, on the other hand, we detect no perceptible progress in his work. With the exception of a brief return to impressionism, c.1943-1946, the 'plein-soleil' period, followed in 1943 by the caricatural 'époque vache', Magritte, from 1927, the year of his rallying to surrealism, painted, almost indiscriminately, masterpieces and works of little attraction; for forty years, however, both kinds remained equally faithful to the rigorous and strange way which—ignoring every fashion—he had chosen for himself.

Malkine Georges (Paris 1898 - Paris 1969). A member of the first surrealist group, between 1926 and 1933 he produced paintings not lacking in charm. But a desire to travel proved irresistible, at least for a time, and his painting was not seen in Paris until 1966.

Mandiargues André Pieyre de (Paris 1909). 'I see you through this red glance—In the chilly instant of your nudity—Surrounded by reeds of golden orioles and trout.' Mandiargues has taken part in surrealist activities since 1947. His precious, perverse, solemn style is equally surprising in poetry (*Dans les années sordides*, 1943; *Astyanax*, 1957), in the short story *Soleil des loups* (1951), in the novel *La Moto-cyclette* (1963) and in art criticism.

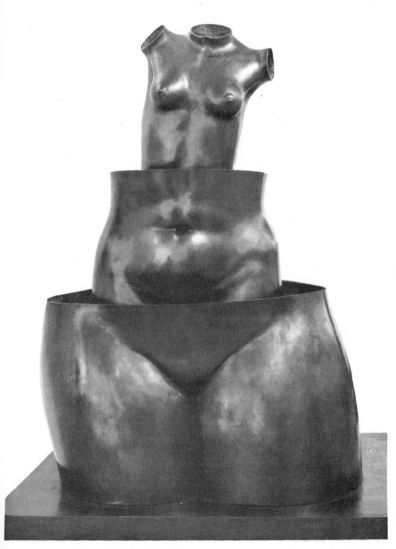

Magritte. Delusion of Grandeur. 1967. Bronze.
Galerie Iolas, Paris.

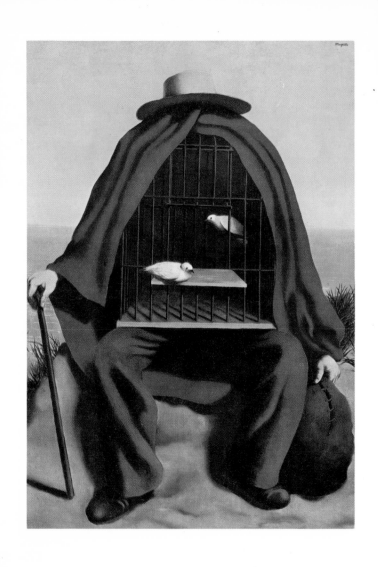

Magritte. The Therapeutist. 1937. Urvater collection, Brussels.

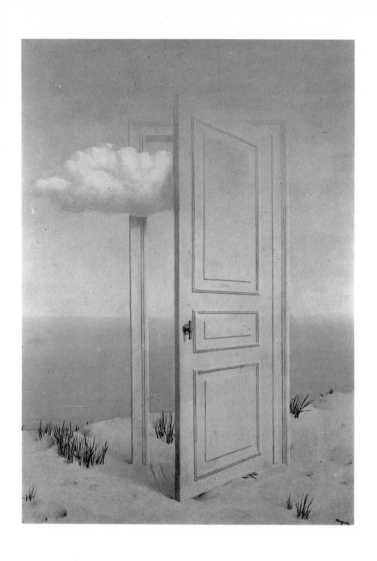

Magritte. Victory. 1939. Private collection, Paris.

Mansour Joyce (Bowden, England, 1928). 'You do not know my night countenance—My eyes like horses intoxicated with space—My mouth splashed with unknown blood...' In her first volume ('*Cris*,' 1952), Joyce Mansour introduced into surrealist poetry a joyful yet sombre note of frenzy, a sadistic and fragrant joviality, something like the systematic culture of the rarest carnivorous orchids (*Les Gisants satisfaits*, 1958; *Carré blanc*, 1965).

Maria Maria Martins, *called* (Campanha, Brazil, 1900). The riotous abundance of flora and fauna in the virgin Amazonian forests appears to have found its immediate echo in Maria's sculpture as Breton 'discovers' it in New York (1943). And Maria at that point assumes a rôle comparable to that of an equatorial fertility goddess. Even later, when a certain serenity appears in her work, it still retains its old vitality.

Marseille (the Marseille pack). At the end of 1940, the surrealists who found themselves at Marseille invented a new pack of cards. The traditional suits are replaced by Love, Dream, Revolution and Knowledge, Kings by Geniuses (Baudelaire, Lautréamont, Sade, Hegel), Queens by Sirens (the Portuguese nun, Alice, Lamiel, Hélène Smith), Knaves by the Magi (Novalis, Freud, Pancho Villa, Paracelsus), the Joker by Ubu. Brauner, André and Jacqueline Breton, Dominguez, Hérold, Lam and Masson produced designs which were executed by Frédéric Delanglade.

Martini Alberto (Oderzo 1876 - Milan 1954). One of the most talented representatives of late Symbolism, he illustrated Edgar Allan Poe with fifty striking drawings (1905-1908). In Paris, 1928, he made contact with the surrealists, and the results of this impetus were some disturbing paintings (c.1930) exploring the fascination of the human gaze and its haunting repetition.

Marvellous (The). 'Let us speak out: the marvellous is always beautiful, everything marvellous is beautiful, there is even only the marvellous that is beautiful' (A. Breton, 1924).

Masson André (Balagny, Oise, 1896). Masson occupies a unique situation among the first painters who rallied to surrealism since, in the first place, he has remained a total stranger to Dadaism and in the second, the de Chirico influence on him is less noticeable than on Ernst, Tanguy, Magritte or Dali. But in a picture like *The Four Elements* (1923), we are aware of a symbolic cubism. Happily these allegories, though by no means lacking in gracefulness, were to be upset by the introduction of automatism when the dynamism of the instincts then comes into conflict with frameworks inherited from Derain and Juan Gris. Masson's indisputable merit is that he was the first—in his drawings of 1924-1925—to surrender himself to the automatic trance with sufficient sincerity to rediscover on occasion the structural characteristics of 'mediumistic' painting. But from

Maria Martins.
Plant rhythm.
Bronze.
Private collection.

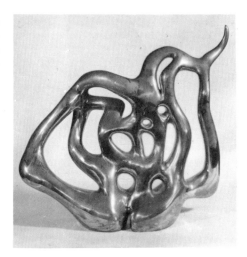

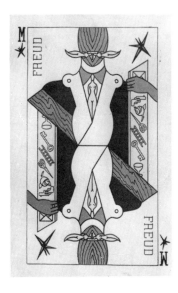

Dominguez. Design for
surrealist pack of cards
(Marseille 1940).
Freud 'Sage of Dreams'
(Jack of Spades).

1926, Miro's example encouraged him—almost by definition the painter of profusion and redundance—to have recourse to the elliptical line, the sign, the synthesis. The result is a certain impoverishment of the pictorial dynamic, perceptible even in his 'sand paintings' of 1927, which nevertheless constitute Masson's best production between 1926 and 1938. In 1929, deeming that Breton had not done him sufficient justice in his book *Surrealism and Painting*, he left the surrealist group and rejoined Bataille. But a new rapprochement occurred in 1938. Stimulated doubtless by Dali and the example of Picasso of the thirties, Masson created powerful and chaotic works in which even their bad taste is a guarantee of sincerity. Metaphor abounds, allied to a certain ingenuousness, but the eloquence is sometimes laboured. It was perhaps in his American period (1941-1945) that this inspiration produced its most convincing fruits: the influence of the American scene and Indian mythology was responsible for a new organization of the picture surface which affected Gorky (Pollock on the other hand was influenced by the painting of 1938-1939). Masson's relations with the surrealists came to an end in 1945. In 1950 his 'Asiatic period' begins, during which he undergoes the influence of Chinese painting. Thereafter, he gives up all effective structuration and surrenders either to impressionist diffusion or a rather empty calligraphy.

Masson. Portrait of André Breton. 1941. Pen and ink drawing.

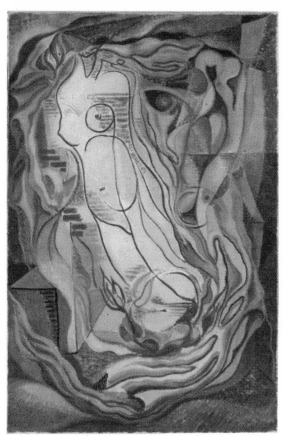

Masson. Amphora. 1925. Private collection, Paris.

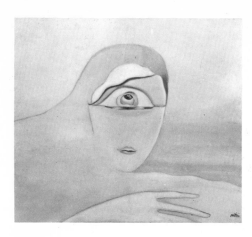

Alberto Martini.
The Romantic.
1930. Galleria
Annunciata, Milan.

Matta Sebastian Matta Echaurren, *called* (Santiago, Chile, 1911). During a journey in Spain, Matta encounters Lorca who gives him a letter of introduction to Dali. Dali, in his turn, introduces Matta to Breton whose welcome revolutionizes the life of the young architect (he had previously collaborated in the plans for Le Corbusier's 'Cité Radieuse'). He becomes a surrealist, a painter (1938). With Onslow-Ford and Francès, Matta represents the new wave of automatism in surrealist painting on the eve of the Second World War. Their god is Yves Tanguy. A few months later this neophyte painter had produced a series of canvases—the 'psychological morphologies'— which have a technical freedom and unprecedented effulgence of colour. Thus, on his arrival in the U.S.A. in 1939, he was to exercise a rôle of paramount importance in the life of the exiled surrealists as of American artists (Gorky in particular) for

whom automatism came like a revelation. To start with, interior exploration merges with a cosmic exploration of irresistible sumptuousness and lyrical power. (*The Earth is a man*, 1942; *The Vertigo of Eros*, 1944, Museum of Modern Art, New York.). The eye plunges down a virgin and vertiginous space in which all limits are annihilated. Screens divide up the third dimension only to vanish before our urge to gain a better view, to see beyond what our sight normally offers. After 1944 a profound change occurs in Matta's work: man comes on the scene, but it is a torturing and tortured man, often amidst the most aggressive machinery, surrounded by the crackling of high voltage electricity, interpreting the specific terrors and obsessions of mid-twentieth century humanity. The means are no less sumptuous than before, but—to the extent to which they put themselves at the service of a humanist and most

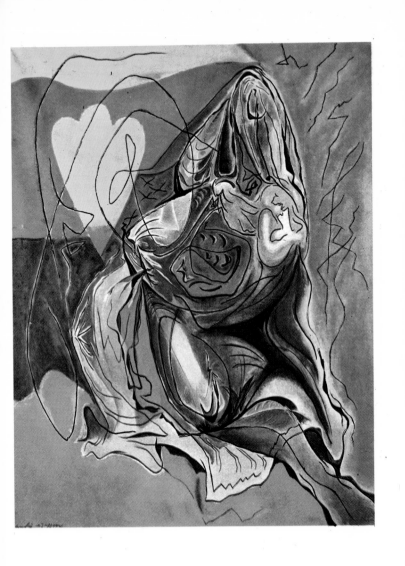

Masson. Niobe. 1947. Galerie Louise Leiris, Paris.

praiseworthy aim—we may regret the diversion of a certain amount of lyrical energy and some loss of the total 'automatic' licence in which Matta previously indulged. In 1948 Matta was expelled from the surrealist group since—in yielding to the 'vertigo of Eros'— he shared some responsibility for the emotional scandal which had recently played a part in Gorky's suicide. It affected him deeply, but it did not interfere with his attachment to surrealism and revolution. However, his pictures increasingly reflect his political concern, if only in their captions. Finally, on the occasion of the inauguration of Jean Benoit's surrealist figure 'Execution of the Testament of the Marquis de Sade' in 1959, he became reconciled with Breton and his friends. The generous lyricism, Matta's particular characteristic, continues to inspire his fulgurating canvases; he even spends his everyday life in an atmosphere of sparks and laughter.

Mayoux Jehan (Chevres-Chatelars 1904). *'Quand je serai enclume—je laverai mon linge à la rivière'* ('When I am an anvil—I shall wash my linen in the river'). Surrealist poet, teacher and militant trade-unionist, he refused to obey his call-up in 1939. His spontaneous and ingenuous verses have the ring of sincerity: the exemplary qualities of children's verse are extensed to adulthood (*Ma tête à couper*, 1939).

Mesens E.L.T. (Brussels 1903 - Brussels 1970). *'Je veux une chemise blanche—Pour me promener dans la fange'* ('I want a white shirt—To

Mesens. Bad Angel. 1963. Collage and crayon. R. von Holten collection, Stockholm.

walk about in the mire'). He renounced music for poetry and played a leading role in the introduction of surrealism into Belgium, then into England. His great competence in art matters involved him in the organization of many important exhibitions. His poems reveal a light and illusive humour tinged with melancholy (*Alphabet sourd aveugle*, 1933), *Troisième front*, 1944), like his collages, characterized by a restrained tenderness and a great freedom of execution.

* *Copies of this famous review were on show in the Exhibition 'Hommage à Tériade' Paris, summer 1973, in the Grand Palais. Tériade collaborated with Skira in the production from No. 1 (février 1933) to No. 9 (octobre 1936).*

Minotaure.* Founded by Albert Skira, this luxurious review (twelve issues, 1933-1939) soon passed into the control of the surrealists, who used it as an admirable instrument of investigation in the numerous fields into which their curiosity led them. Breton, Caillois, Éluard, Heine, Mabille, Péret published texts of outstanding importance in its pages. Picasso and the surrealist painters were brilliantly represented. Each cover was designed by a different artist. For quality and brilliance *Minotaure* has never been surpassed.

Miró Joan (Barcelona 1895). The Catalan landscapes and still-lifes of Miró's so-called *'détailliste'* period,

preceding his final conversion to surrealism, that is to say, to the Miró with whom we are familiar, are of a very engaging charm because of the poetic intensity of each element (1918-1922). Even without this conversion, the lyrical quality in this Catalan painter would probably have attracted the attention of the surrealists. But in crossing the line which separates even the subjective observation of the 'external model' from the orchestration of freely invented signs springing from an exuberance of staggering ingenuity, Miró may be said to have supplied a brilliant proof of the explosive resources that automatism was capable of introducing into the field of painting. At the start (1922-

Matta.
Success to the Glazier.
1947. Drawing.

Matta. Elinonde. 1943. Thomas C. Adler collection, Cincinnati.

Miró. Pen and ink drawing. 1924.

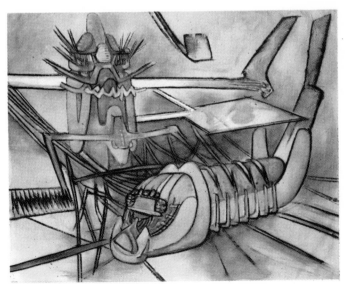

Matta. Who's who. 1955. Private collection, New York.

1924), the metamorphosis was brought about by a distortion which destroys the ordinary relations between objects on the one hand and between objects and space on the other. Thus, space as conceived by Miró in this automatist vein, presents itself straightaway as a two-dimensional flat space on which all the objects exist on an equal footing (*Harlequin's Carnival*, 1925, Albright Gallery, Buffalo). Shortly afterwards we note a step in the opposite direction which leads the Catalan painter to compose a spontaneous pictorial alphabet of emotions—using spots, splashes and arabesques. This invention of signs, inspired by sheer exuberance, counterbalances the results of lyrical distortion. From the convergence of this double approach results (1926)

painting of remarkable lyricism and plasticity, capable of treating existing forms and themes with unfailing success (*Dutch Interiors*, 1928). But at the very moment when he achieves this synthesis of plastic means, Miró declares his wish to 'assassinate painting', and purposely confines himself to austere exercises, as if thereby endeavouring to punish himself for his own creative euphoria (1929-1939). Nevertheless, the years in question can claim several collages and objects that set the seal, as it were, on this guilty euphoria. Painting comes into its own again, but at the expense of a reappraisal that takes the form of contradictory explorations. Thus, a series of works based on collages of vignettes of tools (1933) which confirm his ability to 'abstract' in

Miró. Composition. 1928. Pen and ink drawing.

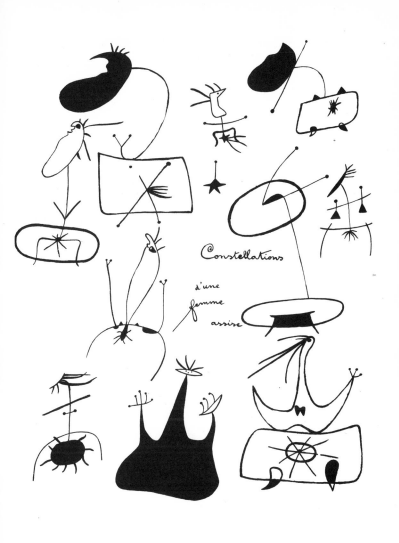

Miró. Constellations of a seated woman. 1938. Indian ink.

Miró. Woman. 1932. Galerie Maeght, Paris.

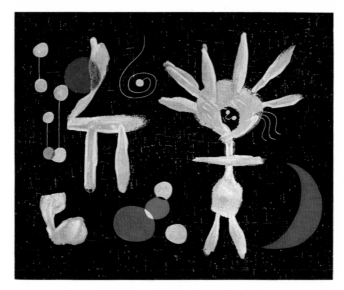

Miró. Morning dew in the moonlight. 1947.
Private collection, Paris.

Miró. Catalan landscape,
the huntsman. 1923-1924.
Museum of Modern Art,
New York.

painting, is succeeded by savage paintings' (1934-1936) in which aggressiveness and anguish are the predominant note. Paradoxically, *Still-life with the old shoe* (1937), the masterpiece of this phase, endows the humblest reality with implications that derive from an experience of the 1918-1922 period. The outbreak of World War II moved Miró to produce his purest hymn of hope, *The Constellations* (1940-1941), a series of gouaches, of small format but great intensity, which later were the inspiration behind Breton's final collection of verse. Since then, Miró, who has become one of the world's front-rank artists, has never ceased to demand of himself a constant renewal in painting and sculpture, ceramics and engraving, while still remaining, as Breton puts it 'the finest feather in the surrealist cap'.

Moesman J.-H. (Utrecht 1909). From 1930 to 1935, the examples of Magritte and Dali reinforce the pictorial hallucinations of this solitary who remained unknown up to 1960 when a Netherland surrealist activity began to revolve around him and Her de Vries.

Molinier Pierre (Agen 1900). A carnal obsession governs his work as it does his life so intimately, so permanently that the spectator feels uneasy in front of his canvases. The woman—often a multiple image— who is the perpetual heroine of his painting, beautifies herself with every cosmetic aid and all the lace trimmings of the woman-object who is eternally out of reach,

and refuses to satisfy desire in order that it shall be maintained in a permanent state of incandescence.

Moreau Gustave (Paris 1826 - Paris 1898). 'The discovery of the Gustave Moreau Museum when I was sixteen permanently conditioned my way of loving' (A. Breton, 1961). The interior shudder which possesses Moreau as he evokes his mythical creatures is realized in tempests of colour and the semi-mediumistic orgies of the convoluted line.

Moro César Quispes Asin, *called* César (Lima 1903 - Lima 1956). 'Every notion of black is too feeble to express the long wailing of black on black as it glows brilliantly.' He participates in the surrealist activities in Paris, 1929. In Peru he founds the review *El uso de la palabra* in 1933. In Mexico City, 1940, he organizes with Paalen an international exhibition of surrealism. His poetry is flamboyant and tortured (*The Castle of Grisou*, 1943; *Love letter*, 1944; *the Sea horse*, 1957).

Nadja. The encounter with a strange young woman, Nadja, reveals to Breton the permanent mystery of everyday life. This mystery has the power to manifest itself under the sign of love or in the presence of those beings particularly spared from the wear and tear of banality. But the mystery exists and on the publication of this brief account (1928) in which descriptions are replaced by photographs, Breton asks himself the

question: 'Is it true that the "beyond", *all* beyond is present in this life?'

Naville Pierre (b. 1903). In 1925, he cast doubt on the possibility of surrealism in painting which led Breton to reply with his book *Surrealism and Painting*. Naville was the first among the surrealists to involve himself in political action (*Revolution and the Intellectuals*, 1926) and later he became one of the founders of the IVth International (Trotskyist).

New Realism. This movement, founded in 1959 by Yves Klein and the art critic, P. Restany, borrowed various elements from surrealism but altered their significance. The 'surrealist object', for example, with Arman and Spoerri, changed from metaphor to metonymy; the 'décollage'* of posters (described in 1935 by Léo Malet) became a sociological constat (Hains, Dufrêne, Rotella, Villeglé); the case instituted against the machine from Jarry to Duchamp turned into an amusing parody (César, Tinguely). On the other hand, Martial Raysse continued the Magritte condemnation of imagery, and Niki de Saint-Phalle's imagination produced some superb and grotesque progeny.

Objective chance. 'The attention that on every occasion I have endeavoured to call to certain disturbing facts, certain overwhelming coincidences in works like *Nadja*, the *Communicating Vessels* and in

* *Use of strips of posters as works of art—a kind of reversal of 'collage'.*

various previous communications, has resulted in raising—with a wholly new urgency—the problem of 'objective chance', in other words the sort of chance through which is manifested—still very mysteriously for man—a necessity which escapes him although he experiences it as a vital necessity' (A. Breton, 1935).

Object (surrealist). In 1924, in 'The Introduction to the discourse on the slenderness of reality', Breton proposes to make and circulate 'some of these objects we see only in dreams'. We have to wait until 1930 for Giacometti with his *Hour of Traces* to provide the first reply to this proposal. Immediately Dali advances the idea of the 'surrealist object intended to function symbolically', several examples of which were then executed by himself, Breton, Gala and Valentine Hugo (1931). What these various objects share in common is the hint, or rather the effective realization of an impulse of an erotic nature. We should not therefore be surprised at the considerable debt they owe to reflexions on the 'found object' which occur so frequently in Breton's texts from *Nadja* (1928) onwards which tend to show that the 'trouvaille' (the 'find') is the reply to a generally unformulated question in relation to sexual desire. Unfettered by exigences of 'symbolic function', the surrealist object presents an almost unlimited field of exploration and one, moreover, which is open to everyone since, realized for the most part with the help of trivial materials, the assemblage of which offers no serious

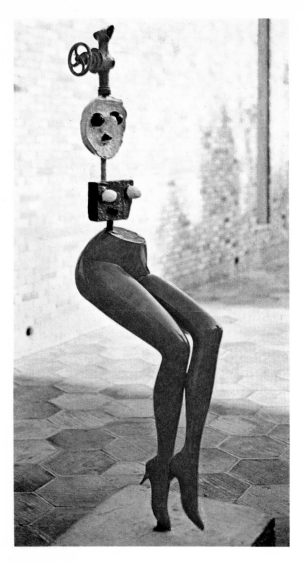

Miró. Girl escaping. 1968. Painted bronze.
Fondation Maeght collection, Saint-Paul-de-Vence.

technical problems, it does not require the slightest artistic talent. However, despite the abundant crop of examples (the most famous come from Brauner, Dominguez, Miró, Meret Oppenheim, Paalen, Seligmann, Tanguy) we can question whether the surrealist object has in fact been fully exploited by the surrealists. Rather are we left with the impression that it was considered as a diversion by the surrealist painters instead of being—as Pop Art and the New Realism were to understand it—a veritable engine of war against traditional painting and sculpture; we should add, however, that these last mentioned movements emptied the surrealist object of most of its poetic content.

Oceania (The South Sea Islands). 'Oceania ... what magic this name has enjoyed among the surrealists. It has been one of the great lock-keepers of our heart' (A. Breton). Much more than America and, before that, the South Sea Islands seem the surrealists' chosen land. Not as the 'Paradise Lost' Tahiti represented to Gauguin, but, because of the astounding rapport that Oceanic art established between an intensely living myth and plastic expression taken to its highest degree of originality; and this, despite the existence of a 'programme' imposed on the artist. In surrealist terms the relation between the 'interior model' and the 'exterior model' in Oceanic art is revealed in an incomparable fusion of the imagined and the observable—to their mutual gain. The analogous process, especially noteworthy in the

Paalen. The leaf chair-cover. 1936. Surrealist object.

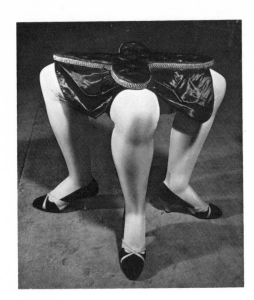

Seligmann.
Ultra-Furniture.
International
Exhibition
of Surrealism.
Paris 1938.

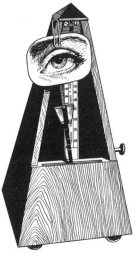

Man Ray.
Sketch reproducing
'Object of Destruction'
of 1932.

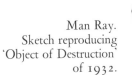

Cornell.
La Taglioni's Jewel-casket.
1940. Museum of
Modern Art, New York.

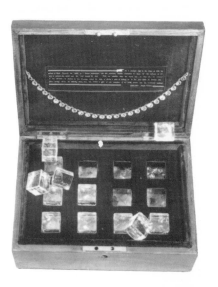

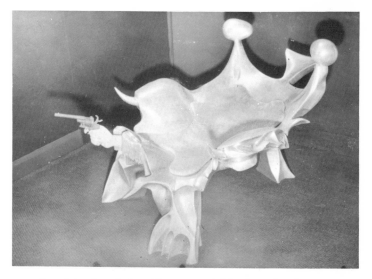

Sterpini. Armchair with an armed Hand. 1965. Bronze.

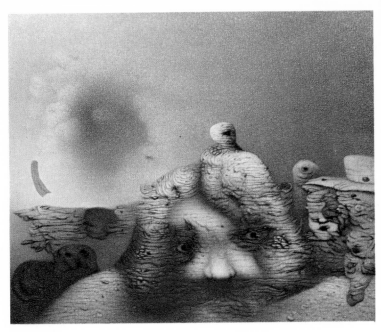

Oelze. The Pleasures of Beauty. 1972. Poppe collection, Hamburg.

Art of New Ireland.
Mask in painted wood
and coloured fibre.
Charles Ratton collection, Paris.

New Ireland *malanggans* in which the mating of fish (shark) and bird (calao) engenders a human face—at work here, as it is in surrealist poetry—extends its power from the fact that the metaphorical spring-board (shark = calao = human face) is completed by a metonymic meaning (shark—ocean, etc.), thus referring us back to a cosmogony in which, as V. Bounoure expresses it, 'the forms of the world make love'. Oceanic art constitutes the most complete justification of the 'poetic (surrealist) view of things' (A. Breton), since it emanates from peoples as free as it is possible to be from every Western cultural influence. Surrealism, thanks to the confirmation that one finds in Oceania (and above all in New Ireland, New Britain and New Guinea) easily persuades itself that its claims concern the whole human race.

Oelze Richard (Magdeburg 1900). He establishes contact with the surrealists in Paris in 1932 and, in 1934, embarks on his completely fantastic work which was to continue unfalteringly, except for the interruption during World War II, up to the present day. Using a process akin to *frottage*, he creates a profusion of plant and animal life, reminiscent of the structures of mediumistic painting. After 1946 his work makes an easy transition to an apocalyptic mood: in vast wind-swept landscapes, imperial cities crumble and prophetic voices announce the wildernesses to come. Or again, on flat stretches of country, leering and malicious spirits rise from behind hedges.

Officina Undici. This is the label given by the painter Ugo Sterpini (b.1927) and the architect Fabio De Sanctis (b.1931) to a workshop for the manufacture of surrealist furniture. The following year they make contact with Breton and his friends who gave them a warm welcome.

Onslow-Ford Gordon (Wendover, England, 1912). This officer of the Royal Navy met Matta in 1937 and from then on devoted himself entirely to painting. On the eve of the Second World War, with Matta and Francès, he represents the offensive directed towards what Breton called 'absolute automatism'. But of these three young painters Onslow-Ford is certainly the one to whom the cosmic dimension comes most naturally. Mineral incandescence bursts from the intersection of bold lines, depths of space arise from the vertiginous rhythm of concentric orbs, volcanoes announce their insurrection. Even when he was enclosed in his Californian solitude, Onslow-Ford was to continue to be lulled by the impetuous flight of comets and be illuminated by showers of shooting stars.

Oppenheim Meret (Berlin 1913). She joined the surrealists at the age of eighteen, became their good fairy, and the subject of some of Man Ray's most beautiful photographs. In 1936, turning her back on her previous charming but hesitant works, she won immediate fame with her first surrealist object the *Déjeuner en fourrure*. Subsequently she was to

construct other objects no less remarkable and attractive but refused to limit the scope of her production and aimed at a kind of allusive and pared-down painting. Her sculpture shows more imagination. Finally Meret Oppenheim organized a 'Banquet' on a nude woman with a gilded face at the International Exhibition of Surrealism of 1959 in Paris.

Paalen Wolfgang (Vienna 1907 - Mexico City 1959). Following austere exercises in which the human being hints at its presence only by an elliptical line (the oval on a face), Paalen's first surrealist canvases, that is from 1935 on, are covered with a uniform and translucid, finely veined tissue which combines the quality of the spider's web with that of the bat's wing. Automatism now raises strange nightmarish totems, now produces mid-air combats of clawed monsters dubbed 'saturnine princes' by the artist. From 1939 in Mexico, Paalen covers his canvases with brilliant showers of meteorites. Later, he was to try to decipher the hidden face of the gods, in their intersecting trajectories. To tell the truth, Paalen, well aware of the latest scientific conquests, was convinced that art and science should work conjointly in their exploration of the universe. And furthermore, his deep knowledge of the primitive arts of North America (in particular those of Mexico and

Oppenheim. Cup, Saucer and Spoon of Fur. 1936.
Museum of Modern Art, New York.

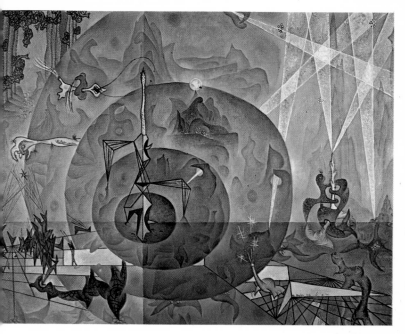

Onslow-Ford. The Painter's Temptations. 1941. The artist's collection.

the North West coast) led him to believe that he should use the art of his time as the vehicle for conveying his loftiest thoughts. Obsessed by these ideas and with the help of some vibrant lines and a few flashes of colour, he composed in 1953 a space that at the same time tragic and sensual, was swept by tempestuous winds. In 1958 his canvases were covered by what looked like flowering shrubs. One stormy night shortly afterwards in a lonely spot somewhere in Mexico City he put a bullet through his heart.

Paranoiac critical activity. Dali first began to elaborate his theory of 'paranoiac-critical activity' in the year 1929. It was proposed to apply the principle of the 'delirium of interpretative association', borrowed from clinical paranoia* and one of its characteristic features, not only to poetic and artistic production, but to the resolving of everyday problems. It was clearly understood that this delirious activity is in fact such only to a certain degree and remains submitted to the control of the intelligence and the will. Hence the value and limitation of the system; without feeling that his reason is at risk in the matter, Dali can take his slightest psychological or physiological eccentricities whose wilful exaggerations are registered in his actions, his writings or his paintings, to a white-heat point with impunity.

Parent Mimi (Montreal 1924). Everything her fingers touch is metamorphosed, and her painting reveals a special predilection for the twilight hour when the grosser animals are asleep and the nycta-lopes and their procession of sprites awaken at the edge of the woods.

Paz Octavio (Mexico City, 1914). *'Quelle herbe, quelle eau-de-vie peut nous donner à vivre?'* ('What herb, what magic brew can give us a reason for living?'). In 1937 he joins the Spanish Republicans and makes contact with the surrealists. Poet (*Eagle or Sun?*, 1950; *Stone of Sun*, 1957) and notable essayist, a number of his writings have been translated into foreign languages. Mexican ambassador to New Delhi, he resigned in 1968 as a protest against the Mexican executions by firing squad ordered by his government.

Penrose Valentine (b. Mont-de-Marsan). 'We will go to the West Indies—Mad Ilse—and see the stephanotis on the iron trellis.' *D'herbe à la lune* (1935) to *Les Magies* (1972), her poetry has maintained its crystalline virtues and its umbrageous grace. Her essay *Erzsébet Báthory, la Comtesse sanglante* (1962), was an exploration of the Hungarian and feminine equivalent of Gilles de Rais.**

* *Paranoiac-critical activity defined by Dali himself as 'a spontaneous method of irrational knowledge based upon the critical interpretative association of delirious phenomena'.* Breton, Surrealism and Painting, *translated by Simon Watson Taylor.*
** *The Hungarian Countess who murdered young virgin girls and bathed in their blood. Gilles de Rais can be said to rival her record. He had fought side by side with Joan of Arc but relished slaughtering children after first torturing them.*

Dali. The Ecstatic Melancholy of Dogs. 1931.
Paranoiac-critical interpretation of a postcard.

Paalen. Painting. 1953. Georges Dupin collection, Paris.

Péret Benjamin (Rezé, 1899 –
Paris, 1959). 'But if the skylarks
queued up at the kitchen door—to
get themselves cooked—if water
refused to dilute wine—and if I had
five francs—there would be some-
thing new under the sun.' Péret
established contact with the group
Littérature in 1920, and according
to legend it was during a 'Dada'
morning in the Salle Gaveau that
he shouted from the pit: 'Long live
France and chip-potatoes!' His
conversion to automatic writing was
instantaneous; and from 1921, his
poems, stories of unrivalled verve
and ingenuousness bear its indelible
stamp and one, indeed, that was to
be characteristic of Péret throughout
his life. None of the surrealist poets
(except Arp) has practised automa-
tism with such consistent success.
Futhermore, the torrential flox on
which his imagery is borne along
re—discovers spontaneously the
accents of popular language, ena-
moured of hyperbole and 'nonsense'—
even when it is limited to invective.
The cascades of metaphor (generally
linked by relative pronouns) which
characterize Péret's language are
inimitable. In addition, they ferry
along indifferently in their dance the
most humble objects alongside those
considered to be the most lyrical by
nature, thus proclaiming that all
words are equal in the poetic trance.
As well as many verse collections,
among which the outstanding are
Le Grand Jeu (1928), *De derrière
les fagots* (1934), *Je ne mange pas
de ce pain-là* (1936) and tales of
irresistible humour in the Mack
Sennett style (*Le Gigot, sa vie, son
œuvre*, 1957), Péret published an

Anthology of sublime love (1956) and
an *Anthology of myths, legends and
popular tales from America* (1959).
He remained to the end, that is for
almost forty years, André Breton's
trusted friend.

Picabia Francis Martinez de
Picabia, *called* Francis (Paris 1879 -
Paris 1953). 'I am the author of
the unrespectable.' After a brilliant
career as a tardy impressionist painter,
Picabia, around 1909, threw him-
self into the surrealist adventure
and, from then on, insisted on con-
signing to the flames day by day
what he had admired the day before.
This led to lyrical outbursts of
unbridled liberty which bore the
title *Udnie* (1913) (Paris, Musée
National d'Art Moderne) and
Edtaonisl (Chicago, Art Institute),
then in New York in 1915, sup-
ported by Marcel Duchamp, to the
first 'mechanical' works in which
the machine is both celebrated and
ridiculed and which anticipates
Dadaist activity. His review *391*
(1917-1924) served as a link be-
tween the various dadaist or para-
dadaist centres throughout the world.
In 1920 Picabia invited Tzara to
Paris and played a decisive role in
the Paris aspect of the movement.
Always quarrelling, he rallied more
to the Breton faction when the latter
broke with Tzara. Nevertheless,
he consistently refused to participate
in surrealist activities. From 1922
to 1926, the period of the 'monsters'
was characterized by an aggressive
verve, undistinguished draughtsman-
ship and strident colours. From
1927 came the 'transparances' in
which superimpositions of conven-

Picabia. Masked Ball, Cannes. 1924.
Robert Lebel collection, Paris.

tional outlines suggest a strange impression of depth. Forced by circumstances during the Second World War to turn out pot-boiler 'nudes', he embarked around 1945 on a very free abstract period which he continued up to his death. Picabia is also a poet who does not allow his humour either to interfere with the fresh vision or dilute the bitter element in his works (*Pensées sans langage*, 1919; *Thalassa dans le désert*, 1945). To the surrealists he was the supreme example of freedom of spirit, perpetual readiness to explore and anti—dogmatism.

Picasso Pablo Ruiz (Malaga 1881 - Mougins 1973). 'Had there been a failure of will in this man, the element in him which interests us would have been delayed if not lost', wrote Breton of Picasso in 1925. In the eyes of the founder of surrealism, there was in fact no doubt that the so-called 'hermetic' period of Cubism (c.1911-1912) was moving so far away from the 'exterior model' that not only was the whole of modern art to be affected by it, but that surrealism's opposition to Western middle-class culture also found in it a decisive stimulus. Reci-

procally, when cubism ceased to be anything more than a decorative formula, Picasso was to discover, among the surrealists who gave him their unreserved admiration, every encouragement to track down his familiar monsters and liberate his erotic phantasms. Thus, all the time that Picasso was to remain in contact with the surrealists, his sensuality, and his plastic sadism, had a free rein, whether during the so-called 'Dinard' period (1928-1929) or in the series of 'sleepers', inspired by the blond nudity of his young mistress (1932-1934), or again later in *La Pêche à Antibes* (1939). Likewise, the disrespectful attitude of surrealism towards easel-painting and the explorations which were to lead to the formula of the 'surrealist object' doubtless played no small part in his conversion to sculpture, particularly between 1929 and 1931. A little later, in 1935, he almost completely abandoned painting to write surrealist poems of an automatic nature. With the outbreak of war, the contortions he inflicts on the female face retain traces of surrealist freedom; likewise the play inspired by the current food shortage which he wrote in 1941, *Desire caught by the Tail*. But his adherence to the French Communist Party in 1944 estranged him from the surrealists, since it committed him to a communist viewpoint.

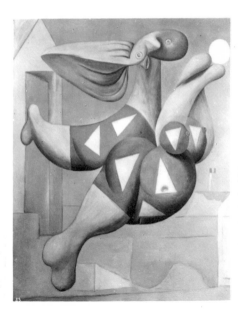

Picasso. Bather playing ball. 1932. Victor W. Ganz collection, New York.

Poem-object. In 1929 Breton describes this procedure which consists in 'combining the resources of poetry and sculpture and in speculating on their reciprocal powers of exaltation'. He was in fact to be the only one to make a valid exploitation of this interpenetration of writing and the plastic element which seems to have given rise to the 'visual poetry' of today.

Poetic image (image, poetic image or metaphor). These three terms are synonymous in the eyes of the surrealists who, furthermore, do not recognize the academic distinction between simile and metaphor. The practice of automatic writing convinces Breton that the 'strongest' surrealist image 'is the one which has the greatest degree of arbitrariness ...the one which takes the longest time to translate into practical language'. Such images had already made their appearance in the romantic poets at their inspired moments; we find examples in Baudelaire and in the Symbolists such as Maeterlinck and Saint-Pol-Roux, in Rimbaud and, *a fortiori*, in Lautréamont whose 'beautiful like the encounter on a dissecting-table of a sewing-machine and an umbrella' was to become the prototype of surrealist image. The surrealists see in the metaphor the very basis of the poetic process and the sign of its values as lyrical information about the world. Thus their concern becomes to blend the esoteric and the magical, whose effects are based on 'analogy' and *'correspondances,'* since according to *Table d'Emeraude** : 'What is above is like what is below,

so that the miracle of one single thing is accomplished. The surrealist image then is a magic *practice.*'

Poetry. 'I continue to see nothing in common between literature and poetry. The former, whether it is directed towards the external world or boasts of introspection, in my opinion, entertains us with rubbish; the latter is all internal adventure and this is the only adventure which interests me.' (A. Breton, 1962.)

Point suprême. 'Everything leads us to believe that there exists a certain point in the mind at which life and death, the real and the imaginary, the past and the future, the communicable and the incommunicable, the high and the low, cease to be perceived in terms of contradiction. Surrealist activity, therefore, would be searched in vain for any other motive than the hope of determining this point.' (A. Breton, *Second Manifesto of Surrealism*, 1929.)

Pop Art. In the U.S.A. the reaction against 'abstract surrealism' happened around 1955 under the sign of Dada with Rauschenberg and Jasper Johns. But Pop art took its real point of departure in the 'readymades' of Duchamp and the work of Magritte, since both seemed to authorize the artist to take the most commonplace objects as models of treatment (Lichtenstein, Warhol). Wesselmann, however, reveals a

* The Emerald Table, *an esoteric work by Hermes Trismegistus, one of the founders of alchemy. The word 'hermetic' is coined from his name.*

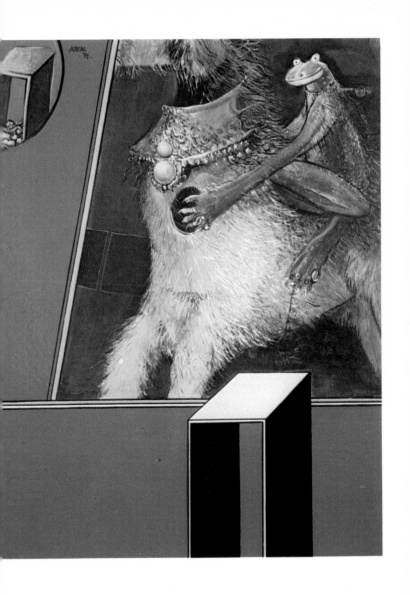

Antonio Areal. Blue Knight. 1971. Private collection.

Cruzeiro Seixas.
The Oppressor.
1959. Plaster,
metal and feather.

spectacularly infantile eroticism, Segal populates the American cities with plaster figures, Jim Dine piles up joke-quotations. Of all the Pop artists, the closest to surrealism are James Rosenquist, whose syntheses of reality are often rich in poetic allusions, and Claes Oldenburg, whose huge and aberrant objects are like extending Salvador Dali and Dominguez ideas to the public square.

Portugal. Surrealism was first revealed in Portugal, 1940, in the paintings of Antonio Pedro, Antonio Dacosta and Candido da Costa Pinto. The year 1947 saw the emergence of the Lisbon surrealist group: the painters Fernando Azevedo (b.1923), A. Dominguez, Moniz Pereira, Pedro, Vespeira (b.1925) were joined by the poets Mario Cesariny de Vasconcelos José-Augusto França, Alexandre O'Neill. The result of this short-lived grouping was an exhibition in 1949 (58 works by seven artists) and the publication of three surrealist magazines. It had, at any rate, the virtue of providing opposition to academism and the current neo-realism (akin to 'social realism') then predominant. But in 1948, Cesariny, believing that the Lusitanian group was neither really a group, nor truly surrealist, took control of an intense collective activity under the name of the 'surrealist guerillas'. As ephemeral as its predecessor, this group was particularly noteworthy for two exhibitions, in June-July 1949 and June-July 1950, and for the publication of poetry by Cesariny, Antonio Mario Lisboa and Pedro Oom; the outstanding artist was Cruzeiro Seixas. Subsequently the surrealist spirit manifested itself principally in the poetry connected with the

review *Pyramid* in which Natalia Correia, Herberto Helder, Manuel de Lima, Ernesto Sampaio join their seniors. But for some years a surrealist revival has been the work of newcomers: Antonio Areal, Gonçalo, Eduardo Luiz, Antonio Metello, Raul Perez, Antonio Quadros, Jorge Vieira, supported by the pioneers Cesariny, Cruzeiro Seixas and Vespeira. Areal is doubtless the most talented of them all, but it appears that the other artists mentioned show great promise. It should be emphasized that Cesariny, Natalia Correia, Helder, Lisboa and O'Neill are among the best Portuguese poets of today.

Prassinos Gisèle (Istamboul 1920). 'I spat ink into the frying-pan.' Gisèle Prassinos was fourteen when she met the surrealists, who marvelled at her poems in which automatic writing makes a natural link with the spirit of nursery rhymes, with an added aggressiveness (*La Sauterelle arthritique*—the arthritic grasshopper, 1935; *Le Feu maniaque*, 1935; *Quand le bruit travaille*, 1936). Since then she has continued to write tales or novels in a similar fantastic vein.

Prévert Jacques (Paris 1900). 'I phonograph for the splendid idiots of the outer boulevards.' Between 1925 and 1929 surrealist behaviour produced in Prévert its most brilliant challenge to the conventions, its rejection of all compromise. His first important text was *L'Ange garde-chiourme* (1930), followed in 1931 by the thundering *Tentative de description d'un dîner de têtes à Paris-France*. Next, Prévert worked as a cineast (beginning in 1932 with *L'Affaire est dans le sac* by his brother Pierre Prévert), teaming up for many years with Marcel Carné (*Drôle de drame*, 1937; *Quai des brumes*, 1938; *Le Jour se lève*, 1939; *Les Visiteurs du soir*, 1942; *Les Enfants du paradis*, 1945). The success of his poems, set to music by Joseph Kosma, led him in 1946 to publish his first collected verses, *Paroles*.

Queneau Raymond (Le Havre 1903). 'Ah, to browse, ah browse and then live naked—breathing air through one's nostrils.' He participated in surrealist activities from 1925 to 1929 but made a tardy literary début. Its ironic and casual style, as perceptible in his verse as in his prose (*Exercices de style**, 1947; *L'Instant fatal*, 1948) and his novels (*Pierrot mon ami*, 1942; *Zazie dans le métro**, 1959) earned him an immediate and original niche in French literature.

Ray Man (Philadelphia 1890). 'I paint in order to be loved.' After active participation in New York Dadaism, Man Ray arrived in Paris in 1921 where Breton and his friends of the *Littérature* group gave him a warm welcome. But Man Ray found himself obliged to turn photographer to earn his living and indeed became one of the most remarkable experts of the century. In 1922 he invented the 'Rayogram' or 'Rayograph': by placing various objects on sensitive plates be ob-

* *Brilliantly translated into English by Barbara Wright.*

tained mysterious, disturbing effects. Nevertheless, he pursued his pictorial work with all the more freedom, since he regarded it neither as a means to fame nor to fortune. Thus, a good number of his paintings show an engaging casualness. As a side activity he continues to create witty objects of dadaist type, the most famous of which is still *Cadeau* (1921)—a flat-iron with its base studded with nails. For some years now homage has been paid to Man Ray's undiminished inventiveness. He published his memoirs (*Autoportrait*) in 1964.

Remedios Remedios Lissagara Varo, *called* (Angles, Catalonia, 1913 - Mexico City 1963). In 1936 in Barcelona, she met Péret,

became his companion and settled in Mexico with him in 1941. Her painting, which began by resembling that of Dominguez, developed into a very individual fantasy in which daily objects assume strange magic powers.

Revolution. 'The surrealist pact, let it not be forgotten, *is triple*; I consider that the present situation of the world no longer allows the establishment of a hierarchy between the imperatives which compose it and which should be pursued with equal vigour—helping man's social liberation in every possible way, working without respite for the *complete* defossilization of social behaviour, refashioning human understanding' (A. Breton, 1947).

Man Ray.
The Prayer. 1930.
Photograph
on canvas.

Remedios. Solar Music. 1955. Eva Sulzer collection, Mexico City.

Rigaut Jacques (Paris 1899 - Chatenay 1929). 'I will be as serious as pleasure.' This dandy experienced Dada with an affable but distant smile, then surrealism, and suddenly shot himself through the heart as he had been preparing to do for ten years.

Rimbaud Jean-Arthur (Charleville 1854 - Marseille 1891). 'I lower the lights of the candelabra, I throw myself on my bed, and, turning towards the darkness, I see you my daughters! may queens!' In the eyes of the surrealists the 'long, immense and reasoned "derangement" of "all the senses"' to which Rimbaud had recourse implies the practice of automatic writing. But it seems clear that the share of will included in the 'verbal alchemy' is considerable and that it militates in favour of 'arrangement in poetry'. In short, if young Rimbaud's revolt retains an exemplary value, his subsequent behaviour (the Harrar period included), to the extent that it can be interpreted as a proof that the 'seer' had ceased to believe that poetry could 'transform life', is in complete contradiction with the whole object and purpose of surrealism.

Romans noirs. The 'Gothic' novels that appeared in Great Britain in the eighteenth and the early nineteenth century, whose chief authors are Horace Walpole (*The Castle of Otranto*, 1764), Ann Radcliffe (*The Mysteries of Udolfo*, 1794), Matthew Gregory ('Monk') Lewis (*The Monk*, 1795) and Charles Robert Maturin (*Melmoth*,

1820), exercised a profound influence on the whole Romantic movement from Sade to Lautréamont by way of Hugo, Balzac, Borel and Baudelaire. In the 'romans noirs' the surrealists acknowledge and hail the perfect example of the poetic 'marvellous' and the complete negation of the naturalistic or psychological novel.

Rumania. Brauner's activity from 1924 on, followed by the reviews *Unu* (1928-1931) and *Alge* (1930-1933), helped surrealism to penetrate Rumania. The poets Geo Bogza, Stefan Roll, Gellu Naum, Paul Paun, Luca, the painters Perahim and Brauner are its principal architects. In 1930 Brauner settled in Paris; in 1932 he joined the surrealist group. In 1938-1939 it was the turn of Luca and Naum. The activities of the Rumanian surrealists, clandestine during the war, came into the open in 1944-1945 under the guidance of Luca, Naum, Paun, Virgil Theodorescu, Trost and backed by innumerable publications of a lyrical and philosophic nature in the *Editions de l'Oubli* (Bucharest). In 1948 Luca and Trost settled in Paris and up to 1953 took part in Paris surrealist activities. A reflection on love and eroticism seems to be the mainspring of Rumanian surrealist preoccupations.

Sade Donatien Alphonse François, Marquis de (Paris 1740 - Charenton 1814). 'The whole of man's happiness resides in his imagination.' In surrealist eyes de Sade's merit is that he high-lighted the violence of

Kay Sage. Tomorrow is never. 1955.
Metropolitan Museum of Art, New York.

sexual desire in the most brutal manner and showed that the social order is based on its repression. Thus, in celebrating this openly in his books (*Justine ou les Malheurs de la vertu*, 1791; *La Philosophie dans le boudoir*, 1795; *Histoire de Juliette*, 1797; *Les Cent vingt journées de Sodome*, first published in 1904) and aided by his highly rigorous materialist philosophy, he succeeded in levelling the most devastating criticism against the social order and its religious bases. The two men who contributed most to make Sade's work known in the twentieth century, Maurice Heine (1884-1940), then Gilbert Lély (b.1900), have been closely linked with the surrealist group.

Sadoul Georges (Nancy 1904 — Paris 1967). In 1930, under the influence of drink, Sadoul and J. Caupenne addressed an insulting letter to the pupil who passed out top from the Saint-Cyr military school. As he refused to apologize, Sadoul was jailed for a six months remitted sentence. He then accompanied Aragon to the Congress of Kharkov where both signed a renunciation of surrealist activity which, on their return, caused a final break with Breton and his friends. Since then, Sadoul's name has been linked with a monumental *History of the cinema* which is neither dispassionate nor wholly free from errors.

Sage Kay (Albany 1898 — Woodbury 1961). She met Tanguy in 1938 and became his wife. In her painting, as in Tanguy's, the forms stand out clearly in a three-dimensional space. But Kay Sage's universe—as opposed to that of Tanguy—is more urban; she evokes a future, but perhaps already dead, city, as if on the morrow of some mysterious cataclysm.

145

Sánchez José (Venezuela 1938). He describes a fantastic fauna, swarming with erotic or libertarian impulses, released in a humorous atmosphere in which the influence of avant-garde 'comics' combines, as it were, with a remote memory of the drawings of Pre-Columbian America.

Savinio Andrea de Chirico, *called* Alberto (Athens 1891 - Rome 1952). 'Tries to realize in painting what Michaux has realized in some of his poem,' to quote the review *Bifur* in 1929 on the subject of Savinio who had begun to paint only a few years before. Unfortunately, the frenzied invention which is revealed in Savinio is weighted down by an idiom inspired by the post-1919 de Chirico. Thus, the best of Savinio, who was also a musician, is to be found in his strange texts, the first of which appear in the form of lyrical commentary to paintings executed by his brother during the period of his genius (*The Songs of Half-death*, 1914; *Life of the Phantoms*, 1962).

Schehadé Georges (Alexandria, Egypt, 1910). 'He who dreams mingles with the air.' Esoteric and unobtrusive, Schehadé's poetry produces happy results from avidly snapped-up trifles (*Les Poésies*, 1952). In his plays, since *Monsieur Bob'le* (1951), Schehadé has introduced the nostalgia for strange and fascinating rites and mysterious journeys.

Schröder-Sonnenstern Friedrich (Lithuania 1892). It was apparent-ly in the ruins of Berlin in 1949 that Schröder-Sonnenstern, 'son of the sun', began to draw—using colour crayons—strange mythological scenes in which Biblical subjects are unrecognizably perverted by his personal obsessions. To tell the truth, the artist is inspired not only by the Judaist-Christian themes (Adam and Eve, Noah's Ark, Paradise Lost, 'Thou shalt work by the sweat of thy brow,' etc.) but more generally by all the popular clichés of Western culture, suddenly re-animated and transformed by a fresh and corrosive imagination. His quality of pictorial invention, characterized by a masterly command of analogy—nose, ears and chin maintaining, for example, animal identity—happily matches his conceptual invention. Both are revealed as inseparable elements in the convincing delirium which lies behind all the work of Schröder-Sonnenstern, whose existence Hans Bellmer first brought to the surrealists' attention in 1959. The latter recognized in him one of the purest examples of surrealist creativity.

Schuster Jean (Paris 1929). 'All that one wins is lost elsewhere, all that one loses is won elsewhere.' He joined the surrealists in 1947 and soon earned Breton's rare confidence. In 1958, with D. Mascolo, he founded the journal *Le 14 juillet*, the aim of which was to rally the opposition of the leftist intellectuals against the régime that resulted from the *coup d'état* of May 13. A few months before his demise, Breton appointed him as his executor. Schuster next ran the

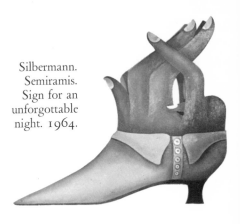

Silbermann.
Semiramis.
Sign for an
unforgottable
night. 1964.

Schröder-Sonnenstern. The Moralunary class. 1956. Private collection.

review *l'Archibras* (1967-1969). In 1969 he published *Archives 57-68, batailles pour le surréalisme* and on 4 October he contributed 'Le quatrième chant' to *Le Monde* in which he asserted that the obstacles which all joint activity based on 'historic' surrealism now met were insurmountable. At the same time he described the search for new angles of approach (such as the review *Coupure* which was his inspiration capable of inaugurating a present, even a future, not unworthy of the glorious hours that surrealism had enjoyed in the past.

Seligmann Kurt (Basel 1901 - New York 1962). Equally obsessed with heraldic symbolism and the esoteric, Seligmann, who participated in surrealist activities from 1934 to 1944, adopted a frenzied style of painting. Draped and veiled figures seem caught up in a turmoil which later was to spread to inanimate objects and even the landscape, in an atmosphere which evokes that of the 'romans noirs.' Seligmann is also the inventor of celebrated 'surrealist objects' such as the *Ultra Furniture* (1938). In 1956 he published the *Mirror of Magic*.

Silbermann Jean-Claude (Boulogne-Billancourt 1935). 'Rien à perdre—que ce venimeux souci—d'insouciance.' ('Nothing to lose—but this venomous care—of carelessness'). He joined the surrealists in 1956 and starting out as a poet, published his first collection 'Au puits de l'ermite' (*At the hermit's well*) in 1958. In 1961 he began to paint and soon invented an original process, ideally suited to the multiplicity of aggressive or joyful images with which automatism inspired him, namely 'Enseignes sournoises' ('sly signs') cut out of wood and painted (1963-1965). Then he abandoned this process in favour of a more objective style of painting suited for emphasizing his metaphors. Next he attempted to reveal a fruitful duality between the objective description ('right hand') and automatism ('left hand') only to return to the 'Signs' in 1970 with a redoubled inventiveness.

Soupault Philippe (Chaville 1897). 'In the eyes of the mirrors and in the laughter of the wind—I recognize a stranger who is myself.' Co-founder with Aragon and Breton of *Littérature*, he collaborated with the latter in the first surrealist book, *The Magnetic Fields* (1919). His verse is airy, elusive, even fugitive (*Westwego*, 1922; *Georgia*, 1926). But these lyrical qualities translated into terms of behaviour testify to a chronic restlessness. And from journalism to the novel (*Le Bon Apôtre*, 1923), from the essay to the memoir, Soupault cheerfully scatters his efforts on the fringes of surrealism until he came to make one of his specialities the exploitation of gaps in his memory.

Styrsky Jindrich (Cermna 1899 - Prague 1942). 'My childhood is my fatherland. My dreams are my fatherland.' Following poetic works of great restraint, Styrsky's collages and paintings, from 1934 on, are astonishing in their erotic violence

and tragic tension. His collages, particularly, have nothing in common—other than the process itself—with those of Max Ernst: where Max Ernst made himself the illustrator of a kind of fantastic novel, Styrsky lays bare his own fantasies with a somewhat cruel lucidity. A similar intensity of vision characterizes his painting. Styrsky's hallucinatory obsessions have been high-lighted in his posthumous collection *Songes* (1970).

Surrealism. '*Noun, masc.* Pure psychic automatism by which it is proposed to express verbally, in writing or in any other way, the true functioning of thought. Thought dictated in the absence of all control exercised by reason, outside all aesthetic or moral considerations.— *Philos.* Surrealism is founded on the belief in the superior reality of certain forms of association, hitherto neglected, in the supreme importance of dreams, the undirected play of thought. It leads to the ultimate destruction of all other psychic mechanisms and to its substitution for them in the resolution of the main problems in life.' (A. Breton, *Surrealist Manifesto*, 1924.)

Surrealism (abstract). 'Abstract surrealism' was suggested by Robert Motherwell to designate what is more currently called 'abstract expressionism', namely the powerful tide of lyrical abstraction which, thanks for the most part to the influence of surrealist automatism (Masson, Ernst, Matta, Miró), swept over American painting in 1943-1944. Not only Gorky, but

Baziotes, De Kooning, Gottlieb, Motherwell, Newman, Pollock, Rothko, Stamos, Still and many sculptors share this same lyrical debt to automatism.

Surrealist. 'In centuries to come, everything in art that aims at a greater emancipation of the spirit through new channels will be surrealist.' (A. Breton, 1950.)

Surrealist (manifestoes). The *Surrealist Manifesto* (1924) put the emphasis on the revolutionary consequences of automatic writing. The *Second Surrealist Manifesto* (1929) stresses the dangers that the abandonment of revolutionary positions represented for surrealism, but at the same time opens up new metaphysical prospects to the movement (the '*point suprême*'). The *Prolegomena to a Third Manifesto of Surrealism or Else* (1942), denounce the surrealist conventions and celebrate the virtues of 'opposition' to all previous or future dogmatism. '*Of Surrealism in its living works*' (1953) recalls the fundamental antagonism between surrealism and literature, insisting on the place accorded by the former to love and poetic analogy.

Surrealist reviews (in France). '*Littérature* (33 numbers: 1919-1924) can be considered the first in date of the surrealist reviews. The first numbers contained *Poésies* by Isidore Ducasse (Lautréamont) and *The Magnetic Fields* by Breton and Soupault. The space given to Dada is constantly counterbalanced by a spirit of investigation and a moral

Silbermann. For the Young Ladies' Pleasure. Sly Sign. 1964.
José Pierre collection, Paris.

Styrsky. The Bathe. 1934. Collage. Private collection, Paris.

preoccupation alien to the latter' (*Dictionnaire abrégé du surréalisme,* 1938). The two important, specifically surrealist reviews, are however, *La Révolution Surréaliste* (12 numbers: 1924-1929), then *Le Surréalisme au service de la Révolution* (6 numbers: 1930-1933). The surrealists contributed later to *Minotaur. VVV* or *Triple V* (3 numbers: 1942-1944) was to be the review of the surrealist regrouping in New York during World War II. Following *VVV, Néon* (5 numbers: 1948-1949) was to mark the revival of surrealist activities in Paris, soon followed by *Médium,* first in pamphlet form (8 numbers: 1952-1953), then as a review (4 numbers: 1954-1955). A relatively glossy review issued at irregular intervals *Le Surréalisme même* (5 numbers: 1956-1959) was doubled by an inflammatory review *Bief* (12 numbers: 1958-1960). A publication of more modest appearance, *La Brèche* (8 numbers: 1961-1966),was interrupted by the death of Breton. *L'Archibras* (7 numbers: 1967-1969), one of the glossiest, ceased publication when serious differences of views arose among the surrealists. Since 1969, J. Schuster, in collaborating with G. Legrand and J. Pierre, has run the review *Coupure* (7 numbers have appeared to date). It was the intention to publish *an International Bulletin of Surrealism* concurrently.

Svanberg Max Walter (Malmö 1912). 'I then hear the thin sound of porcelain women lifting their skirts towards the sky where my heart beats, where the day is bluer

than ever.' It was in 1953 that Breton and his friends discovered the work of Svanberg in which woman is celebrated as by no other surrealist painter. In this work, in fact, woman is the meeting place of metamorphoses with the whole creation, from the plant to the animal kingdom (with particular reference to bird and insect) contributing to define her in a cross-fire of metaphor. Permanent erotic hallucination is here put at the service of a perpetual adoration, which in 'bead-mosaic' paintings and the photo-collage of recent years has never shown any even momentary lapse.

Sweden. The influence of surrealism made itself felt early in Sweden, on the one hand on the poets, Artur Lundkvist (b.1906), Ekelof, Vennberg and Asklund, on the other on the painters, Gösta Adrian-Nilsson, *called* Gan (1884-1965) and Gunnar Löberg (1893-1950). There was, however, no collective activity in the sense the surrealists understand it, despite the Halmstad Group in the thirties, and later that of the 'Imaginists' among whom we find in 1948, side by side with Svanberg, Carl Otto Hultén (b.1916), Anders Österlin (b.1926), Gösta Kriland (b.1917) and Bertil Gadö (b.1916). We should also take into account the activity of individuals such as the remarkable draughtsman Folke Dahlberg (1912-1966), the sculptor Egon Moller-Nielsens (1915-1959), Thea Ekström (b.1920), Sven-Erik Johansson (b.1925) and Ragnar von Holten. But the two personalities in Sweden who, despite

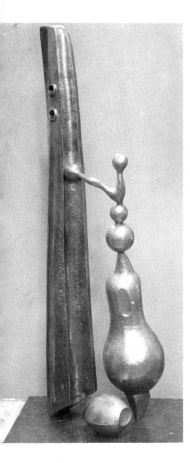

Eric Grate.
The Atlantides mourn
their lost Easter.
1932. Bronze.

their complete independence, are most imbued with the surrealist spirit in art (with the exception of Svanberg) are doubtless the sculptor Eric Grate (b.1896) and the painter Endre Nemes (b.1909). Grate is one of the best representatives of the lyrical freedom introduced into sculpture in the twentieth century. Nemes, starting out with a kind of 'metaphysical' painting, provides a superb example of what Pop Art could be if it were truly impregnated with lyrical feeling.

Tanguy Yves (Paris 1900 - Woodbury, U.S.A., 1955). In 1923 Tanguy—like Breton several years earlier—saw de Chirico's painting *The Child's Brain* in the window of the picture-dealer Paul Guillaume. The shock was such as to lead this ex-merchant navy apprentice to turn painter without any preliminary training. In 1925, along with his friends Jacques Prévert and Marcel Duhamel, he joined the surrealist movement. His paintings at that time show a curiously perverted populism'. Then, in 1926, a series of 'automatic' drawings (scratchings, arabesques, loops, tufts, points), transferred to a canvas coated with colour, produce a universe of smoke, brushwood, ghosts, which seem to defy gravity. It seems likely that Odilon Redon's example was not without influence on the genesis of this kingdom of the impalpable. A rough wind flattens the forms on the ground or stretches them over the dunes, but the weirdness of some of the objects, floating or not, emerges at the same time as that of the landscape which both is and is not the

E. Nemes. Legend of a mother. 1970. Private collection.

Svanberg.
Portrait of a star.
Portrait III. 1952.
Bead mosaic.

Yves Tanguy.
Four o'clock
in the summer,
hope. 1929.
Private collection,
Paris.

Breton beach with which it is tempting but unrewarding to associate Tanguy's painting. In 1930 the mists and jelly-fish give way to steep cliffs which resemble fantastic palaces. From 1932 onwards the beach once more is extended on Tanguy's canvases, but now the gales have dropped and the light, though still misty, is clearer. The most striking characteristic of this new period is the piling-up on several levels of objects, the scrupulous painting of which gives us no clue to their identity. Are they jetsam, skeletons blanched on the desert sands, rocks, shells, human constructions, living beings? All that and something else besides: forms arising from accidents provoked by the painter and interpreted with a patient but adventurous brush. Furthermore Tanguy refuses to make any commentary on his painting: he paints—that's all there is to it—and does not think it is anything to boast about. He even accuses himself of every crime on the rare occasions when he succeeds in selling a painting. In the U.S.A. where he settled with Kay Sage in 1939 and was to live to the end of his life, his work proceeded with no interruptions. The only comment one can make is that in his final years the stones (or what look like stones) extend inexorably over the picture-area; as if each additional stone marked one day less for the painter to live. Tanguy's work stands before us today like on the first day—still, silent, sublime.

Tanning Dorothea (Galesburg, Illinois, 1912). When she met Max Ernst in New York in 1942,

Dorothea Tanning. The Sin. 1969. Cloth sculpture.

her painting was already orientated towards the imaginative evocation of her own biography. Thus she delights in describing in scabrous terms the strange transition of the little girl to the adolescent, from Alice to Lolita (*Eine kleine Nachtmusik*, 1946). But from about 1960, this evolution of female adolescence gives way to a confused image of still more disturbing carnal paradises. Dorethea Tanning's most original contribution to surrealism seems nevertheless to be her sculptures of 1969-1970. The forms, made of cloth, felt, lace, fur are strangely equivocal.

Télémaque Hervé (Port-au-Prince, Haiti, 1937). The examples of Gorky and Wifredo Lam led him in 1960 to embark on a highly subjective style of painting, violent, garish in colour, in which he expressed his obsessions with great fervour. The end of 1962 witnesses a development in which impersonally described objects are increasingly charged with the responsibility (somewhat in the manner of a rebus) of conveying the artist's state of mind. Independently of its purely historic interest, it is evident that a similar transformation, provided it had been properly studied, would throw some light on what— despite glaring contrasts of 'style'— reunites the 'automatist' and 'objective' tendencies in surrealist painting.

Thirion André (Baccarat, 1907). A trade-union official and prominent member of the French Communist Party, he moved towards the surrealists and, especially between 1928 and 1934, joined in their activities. His memoirs (*Révolutionnaires sans révolution*), a personal testimony of complete integrity, had the effect of a bombshell when published in 1972. In earlier days he had found an outlet in a somewhat strange erotic work, *Le Grand Ordinaire* (1943).

Tovar Ivan (San Francisco de Macoris, Santo Domingo, 1942). His friendship with the sculptor Cárdenas and his admiration for the latter's work led Tovar c.1968 to discover his own expressive means in smooth and careful paintings in which embraces and voluptuous tortures mingle in space. A setting of lust, served by a refined sense of colour, is in fact the continually renewed theme of these encounters of breasts and claws, sharp points and attractive cavities, closed solids and menacing saws against a black curtain. With Tovar, mental representations of the love-making have finally found their poet (their painter).

Toyen Marie Germinova, *called* (Prague 1902). 'Toyen's whole work has no other aim than to correct the outside world in accordance with a desire which feeds and grows on its own satisfaction' (B. Péret). Following a few naive and popular works, around the year 1925 she met Styrsky, and together they founded 'artificialism'—a lyrical form of abstraction which by no means excludes emotional associations. In 1927-1928 Toyen indulges in experiments of action painting and explorations of material

Yves Tanguy. Infinite divisibility. 1942.
Albright-Knox Art Gallery, Buffalo.

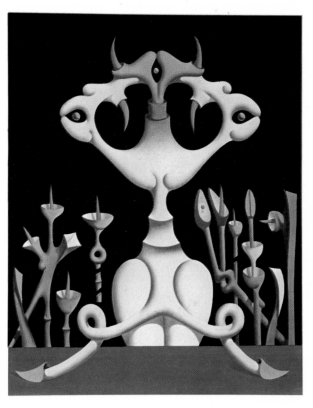

Tovar. The Demon of the virgin forest. 1970.
Private collection, Brussels.

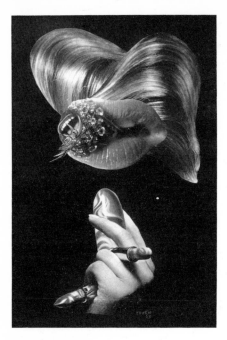

Toyen. In the warmth of the night. 1968. Collage. Private collection

which anticipate the experiments by Wols and others in abstract expressionism of some twenty years later. When, still in association with Styrsky, she joined the surrealists in 1934, she was particularly fascinated by tree-bark, old walls and flotsam. But the 'paranoiac' lesson transmitted through Leonardo da Vinci to Ernst and Dali took an inimitable incantatory form in her work, as if she was attempting to wrench away from these fascinating surfaces beings who are imprisoned in them. From that time on, through varying modifications of her idiom, Toyen remained faithful to this 'magic' technique of

the 'raised ghost'. Doubtless her basic reason for painting is to draw these phantoms out of their cosy invisibility and bring them to the light of day so that they can introduce a slight element of the unexpected into our everyday life. Although she has been living in Paris since 1947, Toyen is the least acknowledged of the great surrealist painters. Her taste for solitude, horror of commercialization, her devotion to Breton and the surrealist group have become proverbial. If her friendly ghosts with their phosphorescent gaze and their disturbing obsessions were seen by a wider public, it would be surprising if they did not

make an immediate appeal since they have a kinship with the characters in the 'romans noirs' and the more poetic 'horror-films'.

Trances. In 1922, prompted by Crevel, Breton and his friends start table-turning. Crevel, Desnos and Péret fall asleep, talk, write or draw in a state of trance. Automatic writing that had been practised for three years, receives a kind of complementary verification from this 'table-turning'. 'The psychological impact on the group—that hallucinatory epidemic among its members—gives the surrealists the crude impression of living at will in a poetic state, of having passed beyond the waking-dream* paradox, and of being the first liberated poetic collectivity' (Durozoi and Lecherbonnier, *Le Surréalisme*, 1972).

* *A reference to the idea expressed by Breton in* Les Vases Communicants *that dreaming and waking are two 'communicating vessels'.*

Tzara Sami Rosenstock, *called* Tristan (Moinesti, Rumania, 1896 - Paris 1963). 'Have you frogs in your shoes?' From the year 1921, Tzara's path deviated from Breton's only to rejoin it in 1929 following the *Second Surrealist Manifesto*. Was it a tactical rapprochement? More than that: the poems written by Tzara in 1924-1925, immediately following the demise of Dada (*Indicateur des Chemins du cœur*) are completely free of Dadaist aggression. As for *L'Homme approximatif* (1930), it is the best existing example of the application of automatic writing to the composition of a full-length poem that possesses epic as well as lyrical qualities. Tzara, the poet, reveals himself as a surrealist by nature. On the other hand, justice is not done here to Tzara, the intellectual pioneer: the undisputed leader of Dada, in surrealism he was merely an uncrowned king. We realize that Tzara felt a certain bitterness about it and was

Picabia.
Portrait of
Tzara.
Drawing. 1920.

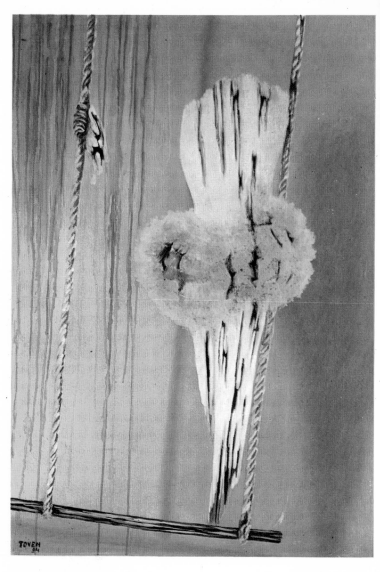

Toyen. The Red Spectre. National Gallery, Prague.

soon (c. 1936) to move away from Breton and his disciples. Only, alas, to suffer a similar rebuff in the French Communist Party, the front rank of which was occupied by Aragon, Eluard and Picasso. It was left, however, to Tzara alone in 1947 to dare to express publicly, in a conference interrupted by the protests of Breton and his friends, the official thesis of the ex–surrealists who had now become Stalinites—namely that surrealism offered the natural way into the French Communist Party. His courage appears to have gone unrewarded.

Ubac Raoul (Malmédy 1910). From 1934 he contributed to surrealist activities with his photo-reliefs, derived from the process of 'solarization'. Figures and landscapes are translated into lines of fire or explosions, the *brûlages* (burnt areas) accentuating their spectral appearance. Then, through the intermediary of Magritte-like drawings in which spots or stains introduce a disturbing element (1945), he ended up with the succinct statements of his engraved slates.

Un dans l'autre (L') ('The one in the other'). This surrealist game, invented in 1953-1954, throws a new light on the mechanics of poetic analogy. 'One of us "left the room" and had to decide to identify himself with some definite object (let's say a staircase). The others had to decide while he was outside that he should represent the

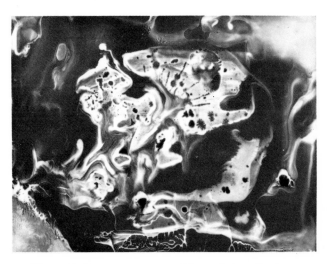

Ubac. Brûlage. 1939-1940. The artist's collection.

object of *their* choice (a bottle of champagne, for example). He would then have to describe himself as a bottle of champagne offering characteristics such that gradually his own image of the staircase should superimpose itself on the image of the bottle and ultimately replace it' (A. Breton). Example: 'I am an overturned baby-carriage containing only a small part of the baby. The latter has recourse to me only on solemn occasions' (definition by Péret: the solution: 'a top hat').

Vaché Jacques (Nantes 1896 - Nantes 1919). 'A man who thinks is curious.' It was in 1916 that Breton met Vaché at a military hospital in Nantes. The distance at which Vaché kept away from everything, including the war, made a deep impression on Breton who drew from this example the remedy (*l'Umour*) against the excesses of the spirit of seriousness at the same time as the urge to question (well before he heard about Dada) art and literature. 'Vaché is the surrealist in me,' he wrote. Vaché could be discribed as Breton's *'Polar star'*.

Vitrac Roger (Pinsac 1899 - Paris 1952). 'The heart is already red as far as the back of the stage where someone is going to die.' With the exception of Artaud, Vitrac is the only surrealist to have had any direct connection with the stage. *Les Mystères de l'amour* (1927) are only, to use its author's words, 'a dialogue of echoes', but *Victor ou les Enfants au pouvoir* (Victor or the children in power)

(1928) pits the genius of childhood against middle-class parental repression with humour combined with poetry. But it is still 'boulevard' theatre like the latter plays (*Le Coup de Trafalgar*, 1934; *Les Demoiselles du large*, 1938).

Waldberg Isabelle (Ober-Stammheim, Switzerland, 1911). It was in New York, 1942, that Isabelle Waldberg was touched with grace before Giacometti's *The Palace at 4 p.m.* Her first surrealist sculptures are boxes or constructions in iron wire. Later she composed for herself a hallucinatory or somnambulist universe inhabited by vague creatures who can never quite tear themselves away from the walls, roofs or planks of wind-swept dwellings to which they cling.

Waldberg Patrick (Santa Monica, California, 1913). He took part in the surrealist activities from 1941 (New York) to 1951. A brilliant chronicler, he is also an essayist of unequal inspiration, according to the company he keeps or to personal grudges (*Max Ernst*, 1958; *René Magritte*, 1965). In 1964, defying Breton's wishes, he organized a Retrospective Exhibition of Surrealism at the Galerie Charpentier.

Yugoslavia. The poet, Marko Ristic (b.1902), introduced surrealism into Yugoslavia in 1924. He made contact with Breton in Paris and his friends in 1926-1927 and, on his return to Belgrade, started an autonomous surrealist activity rallied round the review *Nemoguie* ('the impossible') in 1930.

The participants were mainly writers, and only one painter's name occurs among the Yugoslav surrealists—that of Radojica Zivanovic-Noe (1903-1944)—whose few pictures have great hallucinatory intensity. That does not, however, indicate an absence of interest in plastic expressivity; on the contrary, since the majority of the poets indulged in collage. Among them Vane Bor (b.1908), Ristic, Dusan Matic (b.1898) and Aleksandar Vuco (b.1897), the last three of whom show a marked awareness of the 'photomontage' of the Berlin Dadaists. In 1932 occurred an interesting experiment—the 'paranoiac' interpretation of a flaking wall in which not only Bor and Zivanovic-Noe but also Milan Dedinac (1902-1966) and Rastko Petrovic (1898-1949) participated. Oskar Davico (b.1909) and Djordje Kostic (b.1909) also explored painting, like their friends, as a realm for poetry to conquer. The political orientation which was to characterize Yugoslav surrealism led a number of its members into the resistance movement and later into the entourage of Marshal Tito: Koca Popovic, chief of the general staff; Ristic, ambassador in Paris.

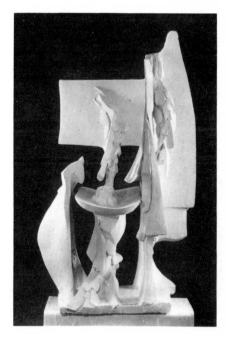

Isabelle Waldberg.
Le grand temps.
1965. Plaster.

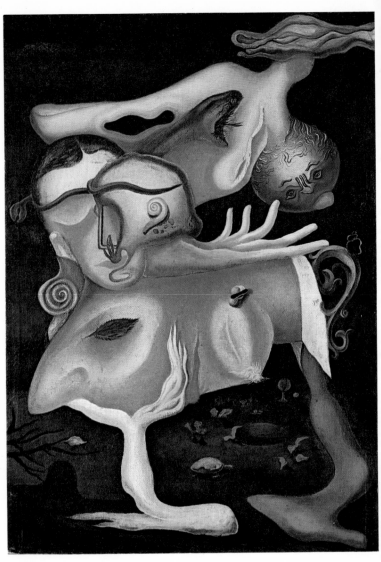

Zivanovic-Noe. The Apparition in the smoke. 1932. Private collection.

Zürn Unica (Berlin 1916 - Paris 1970). 'Who knows if tonight the skeleton will not climb along the ivy up to her window and crawl into her room?' Unica Zürn has related the birth of love in the heart and flesh of a little girl (*Sombre Spring*, 1971). Her shrill and rapid drawings envelop beings in a febrile and wonderful fabric which shares the inevitability of medium-compositions and their power of infinite exaltation.

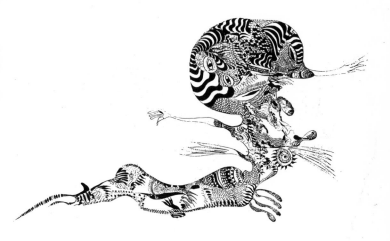

Zürn. Drawing in pen and indian ink.

Sources of Illustration

Albright-Knox Art Gallery, Buffalo: 158
Denise Bellon - *Images et Textes,* Paris: 41, 55, 68, 69, 70a,
 70b, 71, 126a, 130
Paul Bijtebier, Brussels: 60
Robert Descharnes, Paris: 45, 44
Walter Dräyer, Zurich: 32, 136, 150
Gilles Ehrmann, Paris: 85
Galerie Alexandre Iolas, Paris: 105
Galerie François Petit, Paris: 160
Galerie Le Point Cardinal, Paris: 156
Galerie Louise Leiris, Paris: 23, 110
Galerie Maeght, Paris: 124
Thomas d'Hoste, Paris: 55, 57
Marcel Lannoy, Paris: 62
Marc Lavrillier, Paris: 29, 79
Jacqueline Hyde, Paris: 72b, 166
Metropolitan Museum of Modern Art, New York: 51a, 72,
 76a, 127a, 127b, 161
Roger-Jean Ségalat, Paris: 40, 42, 125
John Webb-Brompton Studio, London: 31, 142
E.B. Weill, Paris: 19